Guattari Reframed

Contemporary Thinkers Reframed Series

Adorno Reframed ISBN: 978 1 84885 947 0
Geoffrey Boucher

Agamben Reframed ISBN: 978 1 78076 261 6
Dan Smith

Badiou Reframed ISBN: 978 1 78076 260 9
Alex Ling

Baudrillard Reframed ISBN: 978 1 84511 678 1
Kim Toffoletti

Deleuze Reframed ISBN: 978 1 84511 547 0
Damian Sutton & David Martin-Jones

Derrida Reframed ISBN: 978 1 84511 546 3
K. Malcolm Richards

Guattari Reframed ISBN: 978 1 78076 233 3
Paul Elliott

Heidegger Reframed ISBN: 978 1 84511 679 8
Barbara Bolt

Kristeva Reframed ISBN: 978 1 84511 660 6
Estelle Barrett

Lacan Reframed ISBN: 978 1 84511 548 7
Steven Z. Levine

Lyotard Reframed ISBN: 978 1 84511 680 4
Graham Jones

Merleau-Ponty Reframed ISBN: 978 1 84885 799 5
Andrew Fisher

Rancière Reframed ISBN: 978 1 78076 168 8
Toni Ross

Guattari

Reframed

Interpreting Key Thinkers for the Arts

Paul Elliott

I.B. TAURIS

Published in 2012 by I.B.Tauris & Co. Ltd
6 Salem Road, London W2 4BU
175 Fifth Avenue, New York NY 10010
www.ibtauris.com

Distributed in the United States and Canada Exclusively by
Palgrave Macmillan 175 Fifth Avenue, New York NY 10010

ISBN: 978 1 78076 233 3

A full CIP record for this book is available from the British Library
A full CIP record for this book is available from the Library
of Congress

Library of Congress catalog card: available

Typeset in Egyptienne F by Dexter Haven Associates Ltd, London
Page design by Chris Bromley
Printed and bound by CPI Group (UK) Ltd, Croydon, CR0 4YY

Contents

List of illustrations vii

Introduction: Guattari De-leuzed? 1

Part One: How to critique your milieu

Chapter 1. The clinical milieu – transversality 11

Chapter 2. The cultural milieu – the molar and the molecular 25

Chapter 3. The political milieu – the micropolitics of desire 38

Part Two: How to make yourself a war machine

Chapter 4. The machine 53

Chapter 5. Schizoanalysis 65

Chapter 6. Faciality 76

Chapter 7. The refrain 88

Part Three: How to think chaosophically

Chapter 8. Molecular revolution 101

Chapter 9. Cinematic desiring machines 115

Chapter 10. Ecosophy 126

Conclusion: Guattari reframed 138

Glossary 145

Select bibliography 153

Filmography 157

Index 159

List of illustrations

Figure 1. Balthus, *La Rue* (1933), oil on canvas. 29

Figure 2. Vincent van Gogh, *Portrait of Dr Gachet* (1890), oil on canvas. 71

Figure 3. Shin Takamatsu, *The Ark Building* (1982). 79

Figure 4. Michael Rakowitz, *paraSITE* (2001), mixed media. 107

Figure 5. Michael Rakowitz, *paraSITE* (1998), mixed media. 108

Figure 6. Yoke and Zoom, *Movement art gallery situated on Worcester Foregate Street train station* (2010). 141

Introduction: Guattari De-leuzed?

When people talk about 'Deleuze' they are often referring to Deleuze *and* Guattari, and in even the most dependable of books on their work the latter is often relegated to the role of collaborator or colleague. However, this fact is perhaps unsurprising. Thanks in part to the reticence that each writer displayed in fully articulating their working relationship (often claiming that they were one philosophical machine rather than two people) and also to Guattari's own reputation as an *agent provocateur* rather than a dedicated and methodical intellectual (the French media dubbing him 'Mr. Anti'), his work has been overshadowed by Gilles Deleuze's since the beginning of their collaboration in the early 1970s.

As you will see by the end of this book, however, Felix Guattari's ideas are of major importance not only to Deleuze and Guattari but to twenty-first-century culture – especially visual cultures such as television, cinema, art and architecture. Guattari was a diverse and impassioned thinker writing on a wide-ranging series of subjects, from institutional psychiatry to Japanese architecture, from photography to metalwork and from the attraction of Nazism to the sex lives of Martians! Guattari was a revolutionary, but a revolutionary for the twenty-first century. He believed in what he termed 'molecular revolutions', small acts of rebellion and change that (if carried out on a wide enough scale) could transform the world. He was interested in spontaneous acts of mini-transformation that expressed the desire of both the individual and the group as a way of providing a more authentic counter-argument to capitalist culture. The late twentieth

and early twenty-first centuries saw a series of such acts: the flowers laid at Buckingham Palace after the death of Princess Diana, the public displays of affection in New York during the power loss after 9/11, and the spontaneous dancing of Michael Jackson fans in city centres after his funeral. All of these are testament to the human propensity for molecular revolution, an idea that was most certainly Guattari's.

As we shall look at in this book, Guattari saw in these acts a new form of consciousness, one that had remarkable power and that could potentially engender great political and psychological change. The concepts that he developed in his solo work and in his work with Deleuze, described a society that was only just coming into being. Ideas such as the 'rhizome', 'nomadology', 'machinic heterogenesis' and 'schizoanalysis' are more easily understood in an age of the internet, global terrorism and media simulacra than the period in which Guattari was writing. His death in 1992 meant that he never really saw the predictive nature of his ideas coming to fruition. He never got to see just how relevant his philosophy was to become. This book looks at some of these ideas and finds that, despite their obscure-sounding names, they are strangely familiar and remind us of many structures and forms that we have come to take for granted: hypertext, virtual communities, globalisation and ecological protest groups. All of these come close to the ideas put forward by Guattari almost 40 years ago.

Guattari Reframed, then, is an introduction to his thought through the medium of visual culture, but it is also a form of *How To* guide to living a more philosophically engaged life. Whereas Deleuze was a philosopher in the traditional sense, Guattari was a practising psychiatrist at La Borde clinic in France (an institution he also helped to found when he was only 22 years old). He was also a Marxist and a supporter of a variety of different political groups including the Gay Liberation Front and the Women's Movement. This meant that his ideas were always connected with

the surrounding society and his philosophy always remained relevant, a situation that continues to be the case today. Whereas Deleuze wrote studious and rigorous monographs on Spinoza, Hume, Leibnitz and other philosophers, Guattari wrote on the Gulf War, ecology, drag queens and the working methods of the CIA. His philosophy was experimental but also rigorous, wrestling with certain basic questions that he saw as standing at the heart of what it means to be human: How can we act more responsibly to the weakest in society? How can we combine a respect for the planet with an ethical position on the Third World? How can we treat everyone equally without making everyone the same?

De-leuzing Guattari then, is also an act of reframing and, hopefully, by doing one we also achieve the other. Allowing Guattari the spotlight for a while not only allows us access into one of the most creative and experimental philosophers of the post-war period, but also allows us to trace his lines of influence in the philosophical machine that wrote *Anti-Oedipus* and *A Thousand Plateaus*. In their various interviews, it comes to light that Guattari often provided the raw material for the concepts that Deleuze would later develop; they would swap ideas, exchange letters, borrow concepts from each other and gradually a text would appear. Notions such as the infamous 'body without organs' had already appeared in Deleuze's early works such as *The Logic of Sense* but, equally, a fascination with group consciousness, the machine and the importance of critical thinking appear in Guattari's pre-Deleuzian essays that focus mainly on psychiatry and Freudian and Lacanian psychoanalysis. Understanding Guattari's solo philosophy then is not about divorcing him from Deleuze, but about asserting his place in their partnership and recognising his influence.

Recently, critics and artists have begun to think about Felix Guattari. This is due to some extent to the proliferation of his work being made available through translation, and perhaps also to the overabundance of texts dedicated to Deleuze. However, it is

also an outcome of the realisation that Guattari is becoming more and more relevant. His assertions that simple everyday acts can be both aesthetic and political are finding resonances in cultural life. Whether it is the spray can art of Banksy or the guerrilla happenings of the Improv Everywhere group who inspired hundreds of visitors to London's Trafalgar Square to simultaneously freeze, artists and ordinary people are becoming engaged in what can only be thought of as molecular revolutions, small everyday rebellions that might just change the world.

A life less ordinary

Pierre-Felix Guattari was born in a working-class suburb of Paris on 30 April 1930. When he was in his teens he joined the burgeoning youth hostelling movement, then a hotbed for left-wing radical thinkers. It was here that he was to meet future influences such as Franz Fanon and most especially Jean Oury. His early education was erratic; he studied pharmacology and philosophy at university but dropped out without ever earning a degree. In the 1950s he joined the communist party and became a political activist and contributed to the underground newspaper *Tribune de Discussion*. Throughout his life, Guattari would wrestle with the connections between politics and society and try to redefine the opposition between the individual and the collective.

Based on his burgeoning friendship with Oury when he was 22, Guattari helped to found the psychiatric clinic at La Borde (one hour south of Paris) and became involved in institutional psychotherapy. La Borde became famous for its experimental approach to treating the mentally ill, especially those suffering from psychosis. In a small essay in his book *Chaosophy*, Guattari explains that the techniques he and Oury developed at La Borde (such as the use of art and collective therapy) were intended as antidotes to the dehumanising practices of many institutions throughout Europe. Patients were allowed to express themselves rather than be locked up in padded rooms and were seen as every

bit as vital to the running of the hospital as the staff. However, Guattari stated that he wanted La Borde to be thought of in terms of an asylum, with all the traditional values that word entails.

It was in 1962 that Guattari was to meet Jacques Lacan, the second of the three men that would shape his life (the first being Oury, the last being Deleuze). Guattari studied with Lacan for seven years and would constantly engage and rely on his theories. However, their relationship was always a difficult one theoretically. Lacan's highly Freudian structures failed to fully satisfy the young acolyte, who, even at this stage in his career, was beginning to develop concepts such as schizoanalysis that would attempt to challenge monumental psychoanalytic structures such as the Oedipus complex.

It was this mixture then, of Lacan and Marx, of a belief in the individual and a faith in the group that would characterise Guattari's entire career. In 1969, however, immediately after the seismic cultural shift that was the May '68 protests, Guattari met Gilles Deleuze. Deleuze had just received his Doctorat d'État and was by then established as a conscientious philosopher. The two exchanged letters, talked and decided to write what was to become *Anti-Oedipus*, a text that was like a small explosion in the field of psychiatry and philosophy and would be labelled as 'an introduction to non-fascist life' by none other than Michel Foucault. Deleuze and Guattari wrote three more books together and remained friends up until Guattari's death in 1992.

Guattari maintained his commitment to both La Borde and politics during the 1980s and developed a fervent interest in ecology and environmentalism, even standing for the Les Vertes in the Paris regional elections. Increasingly, he would come to see psychology, politics, freedom, art and ecology as inextricably linked and would publish two books (*The Three Ecologies* and *Chaosmosis*) that would attempt a philosophical synthesis of these through what he termed the 'new aesthetic paradigm'. Such solo projects have recently been taken up by architects,

environmentalists, philosophers and artists as a way of forging a new global identity that aims to be both politically radical and ideologically ethical.

When Guattari died of a sudden heart attack in 1992, the clinic at La Borde fell totally silent for a whole night – a testament to his continuing dedication and commitment to treating the mentally ill with respect and dedication.

Guattari's life and work then, represents both radicalism and compassion. Although he was an activist he was also a philosopher, a point that has often been missing in popular evaluations of his work with Deleuze, evaluations that often view the former as representing some form of disruptive influence on the older man's career – a kind of excitable child who led Deleuze astray. This book attempts to reverse that view, and reframe Guattari as a thinker for a modern age, a thinker whose energy and spirit can be sensed in his writing; someone who advocated examining our everyday processes and engaging in small acts of revolution.

Guattari reframed

This book is divided into three main sections, each of which examines a different stage of Guattari's career. Part One relates to Guattari's mandate of critiquing the milieu that he found himself in. It is centred on the three areas that were most important to him – mental health, culture, and politics. It looks at some of his early essays and demonstrates how they can illuminate our appreciation of areas such as outsider art, the relationship between mental illness and creativity (through artists like Van Gogh and writers such as Jean Genet), the aesthetics of fascism and artistic postmodernism. This part will also examine how Guattari's work can enable us to critique some of the most prevalent theoretical positions of the twentieth century (Freudianism, modernism, postmodernism etc.) and how these can be seen to be linked with some of the most well-known artists and cultural artefacts.

Part Two looks primarily at what could be considered Guattari's experiments in method and ontology. Working with Deleuze during the 1970s and early 80s, Guattari formulated numerous concepts and ideas that attempted to provide answers to the issues that were raised in his earlier career (and were thus also raised in Part One of this book). Notions such as schizoanalysis, nomadology, faciality, and the machinic, allowed Guattari to transcend the boundaries of traditional thought and describe a more poststructural, non-hierarchical way of thinking. The concepts outlined in this section are exemplified using a variety of artworks and cultural artefacts, including the cinema of David Lynch, the self portrait, Islamic art, nomad art, the machinic punishments evidenced in the *Saw* films and the architecture of Japanese architect Shin Takamatsu.

Part Three completes the theoretical journey and outlines how Guattari saw the idea of revolution and the new aesthetic paradigm. In his later life, Guattari became increasingly interested in exploring how we can combine areas such as aesthetics, politics and ecology. For Guattari, every individual has the power to change their lives and the world by engaging in minor acts of revolution – setting up a crèche in the workplace as a way of countering the patriarchal edifices of capitalism, for example, or through the work of artist Michael Rakowitz and his paraSITE project that housed the homeless in specially constructed tents that were attached to the heating vents of big businesses. The last part of this book offers us answers to the questions that were raised in the first.

Felix Guattari was more than one half of a philosophical double act. He was a radical, a revolutionary, a doctor, a Lacanian, an anti-Lacanian, a Marxist, an environmentalist and many more things besides. More than this, as we shall see, he was a thinker of extraordinary breadth. *Guattari Reframed* is an invitation to see the world differently; all you have to do is open your eyes.

Part One: How to critique your milieu

Chapter 1

The clinical milieu – transversality

As will become apparent throughout this book, Felix Guattari wrestled with the same basic issues throughout most of his life. Many of the ideas that appear in his theoretically dense and complex work with Deleuze can be directly traced back to his early clinical writing and his practical experience at La Borde psychiatric institution in the Loire Valley. It is important to note that Guattari was always a practising psychiatrist and psychoanalyst. When he talks of the importance of schizoid flows and the psychotic as an example of social revolution in books like *Anti-Oedipus* and *A Thousand Plateaus*, he is talking from a deep knowledge of what those conditions actually mean. Unlike many of the anti-psychiatrists of the 1960s, however, Guattari never overly romanticised mental illness; his main aim was to understand, to sympathise and, ultimately, to treat those with psychosis or schizophrenia. However, he also recognised that they might have something very important, crucial perhaps, to say about how everyone lives their lives.

This first section is entitled 'How to critique your milieu' because, for Guattari, destruction was the first step to reconstruction. In *Anti-Oedipus*, he and Deleuze wrote that 'the negative or destructive task of schizoanalysis is in no way separable from its positive tasks' (Deleuze and Guattari, 2004: 354) and the same is true of the reverse: the first step to understanding Guattari is to understand how he de-framed, de-limited and detached himself from the traditions that had

preceded him, whilst at the same time retaining their basic elements and structures. Guattari took concepts and changed them for his own ends, adopting and adapting ideas and forms and creating new ones from his wide reading and clinical work. Sometimes this took the form of a simple transplantation from one field into another, and sometimes it represented a complete overhaul or abandonment of an idea or even a whole philosophical system.

The problem with psychiatry

More than anything, Guattari critiqued the psychiatric and clinical milieu that he found himself in. In *Anti-Oedipus*, this would take the form of a full-scale attack on psychoanalysis and the place of restrictive structures such as the castration and Oedipus complexes within the spread of capitalism. However, before he met Deleuze, Guattari mainly focused on the problems and drawbacks of using psychoanalysis and psychotherapy in the clinical environment. He cited four main issues and problems with institutional therapeutics that would resonate with him throughout his entire career:

1. Psychoanalysis relied too heavily on the individuated process of transference between analyst and analysand.
2. Psychoanalysis sought to understand the individual at the expense of the group.
3. Psychoanalysis focused too much on treating the neurotic rather than the psychotic. (More about this in chapter five!) And,
4. Psychoanalysis relied too heavily on the interpretive process of a knowledgeable and all-powerful doctor.

The fundamental problems that Guattari saw in psychiatry and psychoanalysis can be best appreciated if we utilise an example from art criticism.

The relationship between artist and critic has often been likened to that of the analyst and analysand, doctor and patient: there is the same removed contemplation, the same process of interpretation, the same biunivocal uncovering of latent meaning and, ultimately, the same set of methodological and interpretive tools. Freud's monograph on Leonardo da Vinci is an ideal example of the way that art criticism sometimes invites the artist to (metaphorically) lie on the couch so that they can be analysed by a knowledgeable and insightful expert. As ably demonstrated by Steven Levine in *Lacan Reframed* (2008), Freud asserted that the enigmatic smile on the face of the Mona Lisa can be read as the result of da Vinci's longing for the loving look of his estranged mother, Caterina. By attempting to recapture this primal experience in paint and canvas, Leonardo also strove to revisit himself as the desired object of his mother's gaze. Freud finds this inscrutable smile in countless paintings by Leonardo (Saint Anna, St. John the Baptist, Bacchus, Leda etc.) and sees each one as a repeated attempt to capture a moment in time that has been lost forever but has embedded itself in the unconscious of the painter. For Freud, the image is the cipher to understanding the neurotic base of the artist.

Similarly, Melanie Klein discusses the artist Ruth Kjär in her essay 'Infantile Anxiety-Situations Reflected in a Work of Art and in the Creative Impulse' (2004). For Klein, Kjär's choice of subject matter (portraits of her sister, mother and other women) can be traced back to the universal guilt felt by girls during their oral-sadistic phase. For Klein, young girls harbour an Oedipal desire to destroy the body of their mothers in order to obtain the father's penis that exists within. The female equivalent of the castration complex, the girl-child has the innate desire to rob the mother's body of its contents, usurping her place as the desired object of the father and destroying her as competition. For Klein, Kjär's constant dwelling on the female portrait was an attempt to restore the mother's image and assuage her, unconscious

of the repressed guilt caused by the formative desire to attack and destroy her parent. Again, the image here becomes the key to understanding the unconscious of the artist. However, it must first be interpreted by the critic, who looks for signifiers and symptoms of the subjective innate self. The same is true for the analysand on the couch; only here, the dream, the slip of the tongue and the free associations replace the work of art.

So far so good, but what happens when the work is not created by one hand but by many, like the mechanically reproduced artworks that came out of Andy Warhol's factory, or the collaborations of English artists Gilbert and George? How does this impact on the two-way exchange so fundamental to psychoanalytic understanding? How does the idea of the artistic group challenge and undercut the kinds of analytic tools we have been outlining? The process of interpretation and the exchange of biunivocal symbolic meaning (what in therapy would be called the transference) is problematised when we are dealing with many different consciousness and divergent identities, each affecting the other and, in turn, the working of the collective. How can we account for this form of unconscious, the unconscious of the group that interrupts and undermines the sanctity of the Freudian binary?

Can we not also suggest that Leonardo would not only be affected by his mother's smile but by a whole range of different smiles – his grandmother's, his father's, his lover's, the paintings he saw as a child, his own paintings and perhaps even that of the model herself? Should each smile be seen as the same and should each smile be taken in isolation from the many influences that affect an individual throughout their lifetime? In fact, Leonardo could be described as not one self, but many selves, all created by different experiences and different groups of people – a changeable being like everyone else, heterogeneous rather than homogenous.

Similarly, Ruth Kjär's paintings were painted over a lifetime. During that period she would have been influenced by a whole

range of different women, each of whom would have entered her consciousness. Why then did Klein assume her mother to have primary importance? She may have been an influence, perhaps even the most important, but surely not the only one? Kjär too was many people: she was a depressive, a wife, the friend of Karin Michaelis, the subject of Klein's paper, a painter and so on. Each of these people had separate desires and were formed around separate things, but each was also firmly Ruth Kjär.

In a series of early essays, Guattari discusses these issues in relation to institutional therapeutics. Still heavily under the influence of both Freud and Lacan, these early works were the first flowering of what would become a full-scale critique of psychoanalysis and the psychiatric profession in the late 1960s and early 70s. They also provide a vital window onto the more complex theories of his Deleuze period. It is instructive then to follow their development through these early, highly practical, experiences at La Borde and understand how they were shaped by his clinical background.

Guattari (together with his mentor Jean Oury) noticed that one-to-one therapy was inadequate in the large psychiatric institution due to the multiplicity of relationships that any one patient was exposed to. Unlike the bidirectional flow of emotion and information associated with transference and the psychotherapist's couch (the mainstay of Freudian and Lacanian psychoanalysis), the patient in the hospital is exposed to all manner of different relationships and groups (nurses, cleaners, cooks, gardeners, politicians, local authority civil servants and so on), each of which has a role to play in shaping how the hospital runs, and, moreover, in constructing the subjectivities of the patients themselves. Different groups in the traditional hospital setting are assigned different characters and a relative place on a hierarchy of normality – the doctor at the top, the patient firmly at the bottom. Identity then becomes not only shaped but created by one's place in the group and its relation to others. Those familiar

with Lacan will see how Guattari here is both adopting and adapting Lacanian ideas of the big Other and the symbolic register within which we are assigned roles and have subjectivity conferred upon us.

For Guattari, the hospital should not be viewed simply as a hierarchical organism that attempts to treat the sick patient, but as an interconnected web of meanings and energies that pass from one individual to the next, and from one group to another. Traditionally, institutional therapeutics could only deal with this idea in one of two ways, neither of which was particularly satisfying: either it understood the group as a collection of individuals (thus ignoring the power of the group itself) or it understood it *en masse* (thus ignoring the specificity of individual identity). What was needed was a way of thinking about subjectivity without the double bind of privileging either the group or the individual, but at the same time retaining the specific characters of both. Guattari's answer was the notion of transversality.

Transversality was rooted in Guattari's experience at La Borde, and was seen as an answer to the very real problems that he encountered there. However, eventually it would transcend these rather limited boundaries and assume wider significance in terms of general group subjectivity in areas such as politics, aesthetics and ethics. In this one early concept we can detect the embryonic stages of many later notions: the rhizome, schizoanalysis, nomadology, deterritorialisation, machinic heterogenesis and so on, all of which are traceable back to the essays of the early 1960s and all before he ever met, much less talked to, Gilles Deleuze.

Group subjectivity and transversality –
When is a doctor not a doctor?

As Brian Massumi has pointed out, the notion of group subjectivity is misleading when applied to Felix Guattari because it suggests that there might be an opposing theory of individual subjectivity.

In fact, this would be wrong. Even as early as the mid-1960s, Guattari was working on squaring the circle of Freudian and Lacanian psychoanalysis by formulating an approach that saw the individual and the group as consisting of the same basic material – groups are made out of individuals and individuals are both groups in themselves (in that they consist of heterogeneous and fractured parts) and in that they obtain their subjectivity through belonging to a larger collective. For example, if I am a patient in a psychiatric hospital, my selfhood comes not only from a specific illness or condition but from how I am treated by the doctors and nurses. In turn, the doctor's sense of selfhood comes not from any innate 'doctor-ness' but from their role in treating me. Both I and the doctor share a fantasy that binds us to our respective groups and confers our individuated subjectivity upon us. Of course, this process does not stop here. Doctors and patients are part of the clinic-group, which are themselves part of a regional-group, a national-group and so on. As different groups interact, so the subjectivities of the individuals within them change: to the cleaner of the hospital I might be the friendly man who sits on the bed quietly staring into space; to the nurse I might be the difficult patient who refuses to take his medicine; to the doctor I might be the interesting case of acute schizophrenia. I may be all of these things dependent on what group I am encountering at the time, but I am also always myself. My subjectivity is formed somewhere in the space between each of these groups.

Transversality is the degree to which these groups interact, communicate and become open to one another. It is the slipping of the group boundary, the realisation of alterity. In a famous passage from his early essay of the same name, Guattari describes this as working like the blinkers of a horse: in order to encourage those in an institution to fulfil their potential and not to be bound by the normally restrictive nature of groups, it is necessary for them to connect with, and to be able to see, those around them. However, like opening a horse's blinkers, it also

involves a degree of trauma to all concerned: those with institutional power must be willing to give some of it up and those who have previously had very little must accept the responsibility and anxiety that comes with such freedom. Guattari here is as much influenced by Sartre and post-war existentialism as Lacanian psychoanalysis.

Of course, an institution does not merely consist of one level of transversal relations but many. There are a whole range of communicative possibilities and interactions that occur in any large body that affects both its character and the character of those within it. Groups can consist not only of stable and defined categories (doctors, patients etc.) but temporary and self-created groups, such as those formed between friends, those centred around shared interests, families and so on. Examining the levels of transversality within an institution or group allows us to understand its DNA, its unconscious. In effect, it can be psychoanalysed and through various measures, perhaps even treated.

The La Borde clinic attempted to engender such treatment by blurring the lines between the doctors, the ancillary staff, the nurses and the patients: a rota or grid (*la grille*) was drawn up so that essential jobs were carried out by different groups each week. One week your food might be prepared by the doctor and your laundry done by the nurse; the next week it might be a patient or the groundsman. Art therapy was developed and those with severe psychosis were encouraged to communicate through painting and poetry. Every year a show was staged featuring both staff and patients that would ensure that all groups would be in constant communication, listening to each other, contributing to group subjectivity, yet protecting the specificity of the individual by allowing them responsibility and autonomy. At La Borde, everyone, including patients, took responsibility for treating the sick. Each individual contributed to the cure by opening themselves up to the wider collective and crossing that

space that connects us to our neighbour. When is a doctor not a doctor? When they are a cook or a cleaner.

Nicholas Philibert's film *Every Little Thing* (*La Moindre de Choses*) is an ideal visual representation of transversality in action. It is a documentary that was shot at La Borde three years after the death of Guattari, telling the story of their annual dramatic production and the ways in which the various groups of the clinic (from the externally defined groups like doctors and patients to the more temporary *ad hoc* groups like art classes and friendships) were both mutually supportive and intercommunicative. Philibert's sensitive film follows the staff and patients as they stage the Witold Gombrowicz play *Operetta*, and shows how both medical professionals and inmates alike deal with the stresses and anxieties of rehearsals, the memorising of lines and the performance itself. However, what comes across most acutely is the transversal relationships that exist between doctors and patients, sick and well, and ultimately, the film and the viewer.

The documentary opens with what might be considered fairly typical pictures of an asylum. The ill are filmed wandering catatonically around the grounds. Some are in slippers, some are in gowns. Some are conversing with themselves in the stereotypical manner of the Hollywood psychotic – their madness written on their faces and in the way they move their bodies. As the film progresses, however, the identities of the patients gradually change as they cease to become merely psychotics and instead become actors, painters, musicians and acrobats. At times the identities of staff members and patients become blurred, as the transversality of the regime encourages each member of the community to open themselves up to the possibility of change by other groups. At one point, the director of the clinic discusses the rota with the patients, at another a senior therapist prepares a meal alongside those she treats.

The viewer is made aware of the fluid nature of subjectivity under these circumstances but again, we are also shown scenes

of medicine being administered and patients being offered therapy and analysis. Those at La Borde maintained the imperative to treat the sick and to carry out therapeutic action, and this can only be achieved if some sense of the categories of sickness and wellness are acknowledged.

For director Nicholas Philibert, the transversality depicted within the film attacked the rigidity of identities that can be so divisive in the clinical environment:

Most of the time, 'madness' can be seen in people's faces and in their actions. But La Borde also caters for people like you and me, who are simply passing through a fragile moment in their lives. Patients also have responsibilities in the institution, so we don't always know how to distinguish them. Moreover, through the years, some patients have themselves become carer... (Philibert, 2006)

Every Little Thing also depicts a form of stylistic transversality. Is it a film about the mad? A film about theatre? A documentary? A work of fiction? Is it about an art group? The French way of life? Politics? In fact, it is all these things in constant communication with each other. Philibert's film not only allows us to understand the practical genesis of transversality, it also shows how it can be used to interrogate the nature of aesthetics and our relationship to visual images and texts. It offers us paths of communication between genres and lines of flight between layers of meaning and style.

When is a work of art not a work of art?

Recently, the notion of transversality has been applied to artists and artistic groups that extend beyond the usual bounds of aesthetic practice. A number of critics have identified a series of collectives that not only challenge the rigid distinctions between individual and group, but between artistic creation and political activism. Transversality allows us to understand groups like Ultra-red, Continental Drift or the architectural activist group

Platforma 9.81, by offering us insights into the connectivity that exists between the fields of aesthetic and political production.

The 16 Beaver Group describes itself as 'a point of many departures/arrivals' and consists of a number of artists, theorists and political activists who attempt to go beyond the usual distinctions of their respective disciplines, but at the same time uphold them and their specific character. Their work is neither wholly artistic nor non-artistic, but instead plays with the encounters that occur between different groups and attempts to remove some of the rigidity and calcification that institutions such as galleries and museums encourage. As Brian Holmes, one of the group's founders puts it, 'The notion of transversality, developed by the practitioners of institutional analysis, helps theorise the assemblages that link actors and resources from the art circuit to projects and experiments that don't exhaust themselves inside it, but rather extend elsewhere' (Holmes, 2009: 76). We can see here how Holmes defines the concept of transversality in much the same way as Guattari and the other practitioners at La Borde. However, instead of groups of doctors and patients, we have groups of artists and architects, geographers and psychiatrists, fieldworkers and researchers, all encountering each other, communicating and forming different layers of artistic subjectivity and political activism. Later on in the same essay, Holmes directly refers to Guattari's paper on transversality and how the ideas within it, although formed in the clinical environment, influenced him and other artists. Transversal art tends to be both collective (in that it is created by a group or multiplicity of individuals) and encourages communication and cross-fertilisation between disciplines. It often occurs inside the gallery space but breaks that space up by discussing ethico-political concerns as well as aesthetics. Transversal art, however, is more than 'art doing politics', it is a genuine communication between disparate disciplines that encourage creative encounters without damaging the specific character of the discipline itself.

Intrinsic to the ethos of groups like 16 Beaver is that transversality carries its own institutional critique, in that expanding the connectivity between groups of practitioners inevitably weakens the boundaries of the discipline. Suddenly the comforting borders and definitions of what art means and how we relate to it no longer function, and we are forced into experiencing a work through a broader frame of reference. Like Guattari himself, groups like 16 Beaver see transversality as a potentially liberating force that allows for change without the need for the kinds of anarchistic or destructive revolution that characterised similar politico-aesthetic movements such as the Situationists or the bland nihilism of postmodernism. For example, Ursula Biemann's *Black Sea Files* is a gallery-based exhibition consisting of video, photographic stills and fieldwork research that brings together a whole range of researchers and artists to examine the impact of the Baku-Tbilisi-Ceyhan oil pipeline on the economies and communities of the Southern Caucasus and Turkey. The project was first exhibited in December 2005 at the Kunst-Werke Berlin where, as Biemann states:

The piece was installed on synchronised pairs of video monitors, lined up on a long black plinth which ran diagonally across the entire space … A separate video of Azeri oil workers was projected onto one of the walls, contributing to the sonic atmosphere of the installation … (Biemann, 2006: 68)

Black Sea Files should not be thought of purely as a work of art, but as a work of political activism that communicates transversally with artistic practices. In this way it is both a social and aesthetic critique, challenging the rigidity of both sets of institutional practices.

Similarly, Ultra-red are a group of artists and AIDS activists that came together in the mid-1990s to create work that not only discussed issues surrounding AIDS and HIV, but attempted to

change public and political opinion. Using a variety of methods (installations, sound art, photography, theoretical articles etc.), the group continues to exhibit in America and Europe and to expand its political and social remit into areas such as sexuality, public housing and anti-racism. One of its most notable exhibitions was SILENT|LISTEN, a work which was installed in galleries and museums across the US and sought to encourage participants to share their knowledge and experience of AIDS in the gallery space, whilst being presented with extracts of interviews and conversations with those affected by it. Falling somewhere between exhibition and performance, SILENT|LISTEN attempted, as Ultra-red state, to expand the aesthetic experience; emotions such as anger, rage and anxiety (usually, of course, emotions associated with political action) were considered vital to the process of engagement and thus the processes of viewership.

SILENT|LISTEN not only presents the kinds of transversality that encourages different disciplines to overlap, to deterritorialise and to engage in acts of mutual contagion, but it also encourages the development of what we might think of as transversal space between artwork and viewer. It is where each exists as both group and individual, both part of the larger milieu and also as an ever-changing, ever-molecular process of becoming.

So, when is a work of art not a work of art? When it is a sound, or a leaflet, or a space, or a building, or any of the objects or ideas that have made up the works of recent art collectives such as 16 Beaver or Ultra-red.

This chapter has been concerned with one of Felix Guattari's first concepts. As we have seen, he formulated it out of his experiences at La Borde and through the practical problems he faced there. Transversality, however, was a changing thing. Guattari constantly worked on it, updated it and attempted to apply it to different areas and interests: politics, ethics, the self. Interestingly, in an act of conceptual harvesting that is purely Guattarian in nature, artists and theoreticians have taken it in its raw state

and applied it to their own fields, producing something different, yet the same. Time and time again throughout this book, we will be returning to this same basic idea, and exploring how it came to underpin some of the more complex notions that were formed later in his life. Already though, we can see how Guattari's thought not only offers an immanent critique of the milieu but a way of effecting change. Transversality attacks the rigidity of fixed identity by opening up the avenues of communication and connectivity between states and groups. It has been used as a basis with which to understand certain artistic collectives and even the process of creation itself.

Chapter 2

The cultural milieu – the molar and the molecular

We talk a lot about subjectivity and identity in film and art theory, but what do these things mean and how do they work? When you are seated in the cinema or faced with a work of art, who *are* you and what are you experiencing? How can we begin to understand the delicate and complicated relationship we have to visual culture, and how is it linked to the wider social field? Of course, these are all big questions, but in this chapter I hope to answer at least some of them.

Who are you?

In *Anti-Oedipus*, Deleuze and Guattari suggest that subjectivity, your sense of your self, can be formed through two interconnected and yet differently constructed articulations: the molar and the molecular. Your molar self is that which is formed by the large edifices of social production: it is your class, your race, your gender, your nationality, your political allegiances, your culture and so on. This very rarely changes and is often shaped by external forces such as your country, your background, your family group and even your government. Molarity is concerned with mass, with aggregates and with rigidity. It gives structure but can be restrictive; it is well defined and clear cut but encourages simple binaries and oppositions. It has a tendency to divide relationships into 'them and us', into right and wrong or into black and white. Your molar self cheers on your football team, allows you to fill out passport applications and gives you a sense of psychological continuum from day to day. The molar is the big

assemblages of society, the mass structures that both inhibit and provide a basis for identity.

Molarity is an organising force and brings things and people together; it homogenises variety and flattens difference. Imagine a crowd at a rock concert or a rugby match singing in one voice, this is a molar entity. They have in some senses, a single identity, all driven by the same song or the same emotion. Whether this aggregation is based on shared knowledge like the words of a popular hit or a shared goal like the Marxist appeal to the proletariat masses, the crowd exists both as individuals and as a single assemblage. The oneness of the crowd corresponds of course to the oneness of the self in Descartes' 'I think therefore I am', that cornerstone of European psychological molarity that banished the schizophrenic forever into the asylum. It is impossible to be Descartes if you are in two minds!

Conversely, your molecular self is that which exists beyond and behind these simple structures. It is the fluid, ever-changing part of you, the part that is temporary and evanescent but no less important. It is the self that is based in desire and corporeality, the politics of the flesh as opposed to the politics of the mind. If molarity is characterised by rigidity and fixity, then molecularity can be defined by constant flows and free exchange that threaten to disrupt the equilibrium of the self and to blow apart what you think of as the stable 'You'. The molecular is how you are feeling at the moment; it is non-linguistic and defies logical meaning. It is a feeling or a sensation that emerges and then quickly disappears. It is that which allows you to understand how others are feeling – it is the shaper of your life on a day to day basis.

The molecular self is a rhizome, a potato instead of a tree. It works by forming new connections and new centres, growing not upwards but outwards in all directions. Not reliant on a central core, it spreads itself out and produces new avenues and new offshoots, what Deleuze and Guattari would later call 'lines of flight'. The molecular is not opposed to the molar but instead

exists underneath it, constantly attempting to disrupt it, threatening it from within. If the molar entities of this book are the pages, the chapters and the words on the page, then the molecular elements are the ideas that are allowed to flow from passage to passage and from me to you. Like all flows, these can be constructive (you might go out and buy a copy of *A Thousand Plateaus*, read it, and then be transformed by the magnificence of the ideas) or they can be *de*structive (you might tear this page up in frustration) but you can never separate the ideas from the page itself. Let's forget the ebook for the time being!

Molarity and molecularity are vitally important concepts in Deleuze and Guattari's aesthetic thought because they allow them to transcend the normally stultifying double bind of structuralism on the one hand and postmodernism on the other. Since the 1960s, critical theory has battled with this problem, caught between the reductionism of privileging structural analysis over content, and the endless semiosis of postmodern intertextuality that sees everything as a kind of borderless flux without form or meaning. Neither of these positions was particularly satisfying for Felix Guattari who, instead, saw them as being just as bad as each other.

The molar and the molecular are two levels of experience, but neither is reducible to the other and each is equally as valid. Taken from the fields of chemistry and biology, they allow art and film critics to understand the complexity of human subjectivity and its formation without abandoning pre-formed and ultimately useful conceptual categories and tools such as class, gender and race. Although Deleuze and Guattari stress the primacy of the molecular over the molar, unlike postmodernist thinkers such as Jean François Lyotard or Francis Fukuyama, they do not assume large grand narratives to be dead. Rather, it is that when you look close enough they are merely made up of smaller, imperceptible elements that constantly change and transform themselves, thus allowing us to retain the best of both worlds. Guattari especially, in his cultural essays is critical of postmodern artists and thinkers

who ignore the political and social aspects of their work. The refusal to acknowledge the importance of the group and the collective is, for Guattari, a surrender to the primacy of capitalist discourse and an abandonment of the social idealism inherent in his Marxist background.

In their text *A Thousand Plateaus*, Deleuze and Guattari link the twin concepts of the molar and the molecular to all manner of different discourses, from Freudian psychoanalysis to politics, from geophilosophy to art theory. However, they are at pains to point out that we should not think of these as opposite states but different registers, different forms, different aspects of the same thing, as they outline:

There is no question … of establishing a dualist opposition between (the molar and the molecular) that would be no better than the dualism between the One and the multiple. There are only multiplicities of multiplicities forming a single assemblage, operating in the same assemblage: packs in masses and masses in packs. (Deleuze and Guattari, 2004: 3)

Cracks in the street

Felix Guattari evokes these kinds of concepts in his essay 'Cracks in the Street', a paper that examines the Polish artist Balthus and in particular his two works *La Rue* (1933) and *Le Passage du Commerce Saint Andre* (1952/4). For Guattari, we engage with works of art on both a molar and molecular level. On the one hand, we react to concepts such as history, cultural meaning and semiotics, and on the other hand we experience a kind of non-linguistic affect that differs from person to person and from viewing to viewing. It is vital that neither of these two layers of understanding should take precedence over each other. Both the molar and the molecular contribute to what he calls the 'irreducible polyvocity of the expressive components concurring in the production of an aesthetic effect' – in other words, the full complexity of what it means to view and experience a painting or visual image.

Balthus' 1933 work depicts a busy street scene in the Vieux Paris, between Place St. Germain and Place St. Michel. Based on an earlier work, the painting is both cartoon-like and primitive as the figures overlap one another with little respect for perspective or three-dimensionality. A small girl plays with a bat and ball in the foreground, and in the middle a round-faced boy, who could quite easily be a statue or a mannequin, stares blankly out of the canvas, failing to meet the gaze of the viewer. Around him are a series of different people all engaged in disparate activities that seem to keep them from interacting with each other: a man in white carries a plank of wood on his shoulder; a chef in a grey apron stands outside a restaurant on the pavement; and a woman in a black skirt and blouse, with her back turned towards the viewer holds her hand out in a gesture that comes close (as Guattari points out in his essay) to patting the behind of the woman in front.

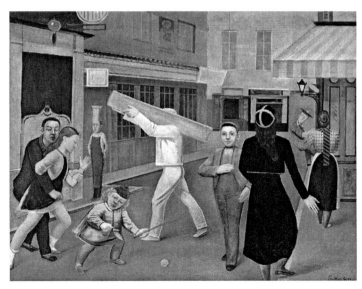

1. Balthus, *La Rue* (1933), oil on canvas.

What is particularly noticeable about this picture is the distinctness of the forms. Each figure resembles those of a *tableau vivant*, a cut out from some other scene. They are separate and yet removed even though they share the same environment. The figures to the left stand so close to each other that they touch, but they seem to belong to different paintings. Their bodies are in contact but are noticeably separate. What is going on here? An embrace? A castigation? A rape? And what is the meaning of the stare of the boy in the middle? His eyes and his gait unnerve and disturb us as we struggle to find meaning in the blankness of his eyes.

Do we not have a multilayered relationship to this picture and by extension to all pictures? On the one hand we are reacting to and appreciating the molarity of its form, line and figuration, understanding its semiotic meaning, its place in the history of art and in the wider cultural field of aesthetics. And yet, on the other hand, we are experiencing the molecularity of its affect and feeling and being struck by the non-signifying, non-articulable sense that arises when we view it – the inexpressible and bodily feeling that we receive from the paint and canvas. The unavoidable sense of the uncanny that pervades the 1933 work is not contained within ready-made structures of form or content but is instead distributed throughout the entire painting: it is in the altered perspective of the background, the muted colours, the blank faces of the characters, the gesture of the small boy being carried by the woman in the black skirt, the way the brush work is invisible in the traces of the paint and so on.

Molecular meaning is not to be limited to the work *per se* but is instead processual, a process that is generated from moment to moment and that also extends into the periods when you are not viewing the painting itself. It is when you are on the journey home, for example, and the memory of the image is still playing on your skin, still working on your flesh, still haunting your mind. The molecular level plays on your senses, eventually becoming part of you – the feel of the painting remains long after

you cease to appreciate it with your eyes. In this way you become one with the aesthetic experience, you have merged with it on a molecular level, like ink and water being swirled in a glass.

Balthus' 1954 painting carries this idea further, as the representation of molar elements become less and less distinct, and the graininess of the style forces the viewer to react to it on a more and more emotive and affected level. Essentially the same scene, the feel is immediately different and the affect more pronounced. We are no longer presented with the molarity of colour and form, but instead the painting takes on a dreamlike quality that is at once disturbing and relaxing. Our gaze is not directed by the internal relationships of the picture (the boy who so disconcerted us before has been exchanged for a young girl with hollow eyes and a pensive look) but is allowed to wander round it, alighting on figure after figure who seem ethereal and otherworldly, barely human even. The figures no longer stand out from the background but instead seem to blend in with it in a fluid fashion. Their faces seem hardly perceptible against the beige and the greys of the buildings that stand behind them. The concrete meaning that was so apparent in the 1933 picture has disappeared and we think that this could be any street in any period of history.

What we do receive from this painting, however, is the sense of flux, of floating, of interchangeable identities and forms. The old woman in the background retains some of the comic nature of the earlier work, but the figure in the front left is little more than a ghost or spectre. Or perhaps they are a memory trace of the earlier picture (could this be the chef, years later, sans hat?). The impression left by this work is of a place between states: living and dead, real and imaginary, comic and tragic, dreaming and wakefulness and so on. The identities of the characters are hard to pin down. For Guattari, the painting invited a more molecular engagement that defied articulate expression but was nonetheless vital to the aesthetic process.

The molecular understanding of a painting fills in the cracks left by the absence of fixed and stable meaning, and we are invited to respond to it on a more visceral, instinctive level. For Guattari, this allowed us to not only understand the complexity of an artist like Balthus but to comprehend the full thickness of the viewing experience. Visual images subtend the normal processes of understanding, namely, the molar constructs of knowledge formation, and appeal to a more fluid stratum that demands new theoretical tools and new ways of framing and re-framing texts. We can see already how different this idea is to the vast majority of critical analysis that we are used to in art and film theory that sometimes attempts to homogenise the experience of viewership and the audience it speaks for.

For Guattari, art was more than a process of contemplation and the viewer much more than a passive recipient of an image or emotion. Art, due in part to its potential for transversally opening up its boundaries, has the power to transform and to change our subjectivity and identity. It allows us to feel, to connect, to communicate and to engage in what might be considered a becoming between artwork and spectator. It makes us question the stability of our existence and, perhaps, exposes us for the multilayered beings that we are. Together with politics, sexuality, ethics and a whole host of other discursive practices, art provides us with the raw material of existence and studying it can allow us access to the ways in which we construct our selves. The answer to the question 'Who are you?' then could perhaps be 'It depends on who you are asking, my molar self or my molecular selves.' As Ronald Bogue states:

The Modern task of molecularizing matter and harnessing forces is the task of all art. Painters have always sought to render visible invisible forces, composers to render audible inaudible forces. (Bogue, 2003: 52)

The two paintings by Balthus hint at an ever-deepening sense of the molecularisation that Deleuze and Guattari see as fairly

typical of modern painting – a constant attempt to make visible the invisible. In his book on Francis Bacon, Gilles Deleuze plumbs this area further offering concepts such as sensation, affect and the violence inherent within the image, but this is a book about Guattari.

It is easy to see from this brief outline how concepts such as molarity and molecularity arose from Guattari's therapeutic work at La Borde. Molar identities such as doctor, patient, nurse, madman and sane were constantly undercut and challenged by the more molecular identities associated with group interaction. Identity was seen as both fixed and fluid, both constant and shifting and notions such as group subjectivity meant that the self could never be thought of as essential and fixed. It is also obvious that both levels of understanding were needed at La Borde if treatment was to be successful and if the institution were not to merely project its own pre-formed identities onto those within it. It was only through manipulation at the molecular level that a change in the molar level could occur. The rigidity of the group and the institution (the molar assemblage) could only be affected through widespread molecular change.

Throughout his life, Guattari was to come back to this fundamental set of concepts time and time again. Whether it was in art, in politics or in ontology, they always offered him a method of challenging what he termed 'the postmodern impasse' of contemporary critical theory, the double bind of structuralism and infinite semiosis.

The unswerving molarity of *Avatar*

Traditionally, film theory has answered the question of viewer subjectivity by recourse to three major areas: politics (especially Marxism and feminism), psychoanalysis (Freudianism and Lacanianism) and semiotics. Robert Lapsley and Michael Westlake's book *Film Theory: An Introduction* is a good example of just how intertwined and ingrained these approaches are to

the area of cinema studies. The entire first part of their book (the part that deals mainly with spectatorship) is given over to an in-depth discussion of these major theories, and what emerges is an image of the viewer as a stable entity, with fixed ideas, solid boundaries and a distinctly structured character. Prompted, we could suggest, by the ideas put forward by the foundational voices of film theory (most notably the *Cahiers du Cinéma* critics of the 1950s and 60s) this conception of the viewer has become one of the discipline's foundational objects, forming the basis of many a book and many a conception of the cinematic form.

We can immediately recognise the molarity of this ideal viewer: whether one is dealing with the political self, the gendered self or the self that engages with meaning and signification, each of these perspectives depends upon the solidity of social aggregation and the rigidity that comes from belonging to a wider group.

For example, in the 2009 Hollywood blockbuster *Avatar*, we see each of these aspects played out simultaneously. It is impossible to miss the anti-imperialist collectivist message that pervades the film that is designed to appeal to a specific eco-philosophical liberalism. It was met with praise and horror in equal measures by contemporary left-wing writers who saw it as either a shining and refreshing example of popular anti-colonialism, or merely as an example of Western hegemonic racism that attempted to paint cultural others as somehow more spiritual and more eco-friendly than the West. The Na'vi people are similar in character to the 'men in a state of nature' that populate eighteenth-century Enlightenment texts like *Robinson Crusoe* and John Locke's *Two Treatises of Government*. They are pictured as innocent, peace-loving, naive and communal, in fact everything that the military scientists are not.

An analysis of *Avatar*'s political meaning might conclude with the assumption that the viewer is sutured into the narrative through their identification and empathy with the social cause of the Na'vi. Further, if you are sympathetic to their position you would enjoy the film, engage with it and see it as a positive

example of political ideology. However, if you were unsympathetic you might see it as a piece of liberal propaganda, limply citing pseudo-spirituality as a way of ignoring the real issues in contemporary society, or perhaps even as a divisive and dangerous incitement to abandon the ideology of the West. Either way, your experience of the film would be guided by the large structures of your molar self – your political affiliations, your cultural background, your place in the world order and so on.

We could approach *Avatar* from a semiotic perspective, seeing in its images a series of signs that we engage with and understand. The religious symbolism, for example, speaks to Western audiences of cultural otherness, the blue speaks to us of serenity, of peace, and the forest is itself a signifier for togetherness and community. Military technology has become a signifier for the power of the aggressor over the weak and so on. These signs may shift throughout the film but they depend on a fixed and stable mind to interpret them and they can be manipulated by the filmmaker for their own ends. The signification of *Avatar*, both on a syntagmatic and a paradigmatic level, relies on the stability that comes from accepted meaning. In other words, a language, even the language of cinema, results from the molar self, the self that connects you to the wider social field. Film theory assumes that when you are seated in the cinema, you are interpreting the signs you are presented with in roughly the same way as your neighbour – it takes homogenisation as a given.

The unnerving molecularity of *Avatar*

One of the problems with the molarity of many film theories is they do not take into account the evanescence and processual nature of cinema itself. Think back to your experience of watching *Avatar* (or indeed any film). What stays in your memory? What are the things that you recall? The chances are that it is not the way you identified with the political situation of the Na'vi people at all, more than likely it is not the ways in which you interpreted that great signifier or the extent that you were presented with that

exciting Lacanian mirror image of yourself. In reality, you probably remember the feeling of the film; the way the sound hit your body because it was so loud; the way the 3D technology made you feel a little sick at the start; the way the colours made you feel; the way the green light of the forest clashed with the darkness of the spaceships; the way that the images of flying made you feel; the way the music worked on your heart or the way the film represented a constant rollercoaster of sensual experience.

As we can appreciate, this is the film working on a more molecular level. Without abandoning the molar assemblages (we can still assert the importance of politics, semiotics and psychoanalysis) we can begin to understand how the experience of the film affects us. We might even study the interaction between the two. For example, how does the molecular experience correspond, undercut or otherwise provide a counterpoint to what the director was trying to say ideologically?

The molecularity of a film like *Avatar* is extenuated by its technology, but is not dependent on it as it occurs in all films. Recently, film theorists such as Barbara Kennedy in her *Deleuze and Cinema* (once again forgetting Guattari, but never mind) and Laura Marks have begun to look at the importance of molecularity in popular cinema and art films especially those that rely on the visceral and the bodily. The body was seen by Guattari as offering a way out of the bifurcated impasse of molar discourse. It escapes the dividing nature of party politics, eliding the binarised systems of signification and encourages a direct involvement on the part of the viewer. In embodied film theory, the viewer ceases being just a pair of eyes looking at the screen, and becomes instead a feeling, sensing, affected surface that transversally engages and experiences with the film on a primal level. Again, however, using critical tools drawn up by Guattari and Deleuze we can twin this with a consideration of the more structural levels.

Many people I have talked to about *Avatar* mentioned that this embodied molecular sense stayed with them even after they had

left the cinema. Some even suggested that it might be addictive, that they went back and saw the film a number of times to relive their first experiences. Many people stated that they felt an undefined calm when watching it, as if they were being wooed by the technology, the colours and the music. At times they were elated, at other times they were unnerved. We could think that this would also be the same in film genres such as horror, where the body, rather than the mind, is the object of the director's attention. When you are jumping at Freddy Krueger, wincing at the pain of Marion Crane or being blasted by the bombs in *Saving Private Ryan* you are experiencing the molecularity of cinema, a layer that is ever-changing, hard to define and difficult to contain.

The molecularity of cinema encourages it to burst its banks, to reach out and form new connections with the bodies and desires of its audience. Music can do this more than any of the arts, becoming one with you, encouraging you to form transversal relationships with those around you through new connections and lines of flight. For Guattari, the arts were more than a distraction. They were a way of revolutionising daily experience, as if we are all composed of micro-activists constantly bucking against the centralising forces of molarity. Guattari encourages us to release the power of the collective whilst still retaining the identity of the individual. Imagine being able to harness the power of the rock concert or football crowd, what worlds we could change!

Guattari's critique of the critical and aesthetic milieu was perhaps less obvious and less structured than that of the clinical, but it was no less powerful and no less positive. As we shall see, it has also been used as the basis with which to revise the critical tools that are used by disciplines such as film and literary theory that often have recourse to notions such as embodiment and corporeality. Due to its utilisation of light and time, film is itself, perhaps a more molecular medium than painting and, as we shall see, it prompts us to examine the whole range of different aesthetic possibilities and deployments.

Chapter 3

The political milieu – the micropolitics of desire

The spectre that haunts the work of Felix Guattari perhaps more than any other is that of fascism. Fascism in its many forms – psychological, political, personal and national, is a constant presence that seems to present both a distant fear that forever threatens to return, and a prompt to find new, non-restrictive, non-totalitarian ways of living. Michel Foucault, in his much vaunted preface to *Anti-Oedipus* stated that the book could be taken as an introduction to a non-fascistic way of life. This chapter takes this statement at face value, tracing the different ways Guattari and Deleuze offered an alternative to the many fascisms of late capitalism and ultimately, suggested how we can avoid the kinds of restrictions it entails in the future.

Historical fascism (the political ideology of Nazi Germany, the Fasci italiani di combattimento, the Falangists in Spain and so on) appears only sporadically in Deleuze and Guattari. However, it does have a major role to play in shaping their understanding of the concept's wider significance to both politics and psychology. Here I would like to study the mechanisms of fascist attraction specifically through its propaganda and in particular, the popular images and posters that were deployed during the Second World War to proliferate and ensure the dominance of its ideology and political identity. Some of these images are extreme in their content, especially to today's eyes, but, as we shall see, they are also complex examples of emotive art that are inextricably bound up with the desires and wishes of its target audience. Like pornography,

propaganda is rich with social desire. Its images are encapsulations of the wishes of its audience and their analysis can tell us not only about the artist and the regime, but also about the surrounding milieu. More than anything, fascist propaganda can provide us with a window into the very relationship between individual desire and the large social machine. This is something that, as we have already seen, was a constant theme in Guattari's work.

Fascinating fascism

One of the central questions of post-war political theory, especially as it is linked to fascism is: what was its attraction and why did millions of seemingly ordinary people not only desire to subjugate those they saw as outsiders but also eventually themselves? However you frame it, both morally and politically, fascism is concerned at its heart with restriction and repression. This, in many ways, is its main ideological feature, a point that was not lost on Benito Mussolini who famously declared that 'Democracy is beautiful in theory; in practice it is a fallacy'. What is it then that makes people want to restrict themselves, to tighten their own laws and to give up their own liberties? Why do populations desire their own oppression? In an age of increasingly restrictive policy (the Patriot Act in the US, the various 'anti-terrorism' legislation acts in the UK, the rise of CCTV etc.), this question is becoming more and more prescient. In fact, it may be *the* political question of our age.

Traditionally, propaganda has been seen as having an active, restrictive and transformative role in the psychic life of a country, and therefore of being a major instrument in the proliferation of a fascist regime. Much like psychoanalysis, it relies on notions such as lack, anxiety and repression, operating on the twin platforms of neurosis and paranoia to spread false information and lies. Its aim is to dupe an otherwise innocent public into actions that are contrary to their basic behaviour. The titles of many books on the area of propaganda are a testament to the generally accepted notion of how it works: *Propaganda: The Art of Persuasion,*

Techniques of Persuasion: *From Propaganda to Brain Washing* and *Soviet Cinema: Politics and Persuasion Under Stalin* all attest to its fundamental role as a shaper and a guider of public opinion. Propaganda, so the theory goes, imposes, or at least persuades the populace into accepting an ideology through a hierarchical, top-down flexing of symbolic muscle. The masses (note: the molar entity) are fooled and seduced in equal measure by an infinitely more resourceful and intelligent state apparatus into swallowing a highly sugared political pill that will ultimately choke them.

This is the theoretical line that many commentators on propaganda have taken. This idea stresses the power of the state over the individual, it appeals to people's molar self, the self that works in large aggregates, such as nationality, culture or race. Let's look at a typical example of 1940s fascist propaganda from the official caricaturist of the Nazi party, Hans Schweitzer, otherwise known as Mjölnir. Schweitzer was appointed to the post of Reich representative for the visual arts in 1936, and as Jeffrey Herf details 'was charged with translating Nazi ideology into "artistic form" and distinctive style in various arenas – uniforms, stamps, flags and posters' (Herf, 2008: 29) Schweitzer's work then is perhaps the nearest we can get to a reification, a making concrete of official Nazi ideology, and is therefore an interesting starting point into discerning the processes whereby it comes to be adopted by a population.

In 1943, Schweitzer produced the anti-Semitic poster 'He is guilty for the war', an image that depicted a stereotypical portrait of a Jewish businessman, complete with the gold Star of David attached to his chest, cowering in a dark corner. An accusing finger points at him and the phrase 'Der ist schuld…' hangs above his head, whilst the words 'am Kriege' are relegated to the bottom of the image, as if Schweitzer is also making an existential point that, for the Nazi party, Jews were guilty of a more fundamental, genetic crime.

The semiotic and ideological inferences contained within this poster are immediately obvious: not only does Schweitzer encourage its spectator to view race and culture as inherently

static and essential, but this is twinned with an attempt to relieve the Third Reich, and more importantly the German people, of their complicity in the war. We have a series of binaries here all organised around a central, simplistic message of racial dominance: German and Jew, right and wrong, innocent and guilty, even to the extent that we can detect light and darkness and white and black in the very colours of Schweitzer's palette. This is standard fare for propagandists, the visual representation of the dividing line that separates us and them. Hitler's propaganda minister Joseph Goebbels was an infamous exponent of art's power to persuade and shape public opinion. In a much quoted phrase he stated that 'the essence of propaganda consists in winning people over to an idea so sincerely, so vitally, that in the end they succumb to it utterly and can never escape from it.'

The traditional way of interpreting this image would be as a persuader, and a propagator of false information. Surely it is no accident that the finger that accuses the Jew of his crimes comes from the highest point in the image – a kind of symbolic rendering of the hierarchy that so permeates the fascist regime. It is thought that if such images are produced in enough weight they will eventually dupe and brainwash the public into accepting the unacceptable.

However, are we to believe this position? Are we to believe that a whole population, much less a great deal of Europe, was fooled by this simple message conveyed in such a simple way? For us to accept the standard pattern of fascist proliferation we have to assume that a small minority of intellectuals could hoodwink millions of right thinking, well-educated Germans into either ignoring or participating in mass murder. We also have to accept that the veil over their eyes was immediately lifted after Hitler's suicide, as if the dolls fell lifelessly to the ground once the puppet master had died. This was the question that Guattari asked in 1964 and the question he was still asking in 1972 when he and Deleuze tackled it in *Anti-Oedipus*. If we rely on an image of the

political as hierarchical and molar, then we assume the masses to be both ineffectual and guilt free in equal measure.

Guattari and fascism

Guattari's answers to the questions above can be split into three main areas: those arising out of his solo pre-Deleuze work at La Borde; those arising from *Anti-Oedipus*; and those arising from *A Thousand Plateaus* and beyond. Each of these approaches offers us something different by way of understanding fascism and the propaganda that underpinned it. However, for the sake of clarity and brevity I will offer a hybrid reading of *Anti-Oedipus* and *A Thousand Plateaus* here, using them both as a continuously evolving strategy rather than the distinctly different framework that each text actually represents. It should be obvious that this distinction (between early and later Guattari) corresponds roughly to the difference between the first two chapters of this book – the first period stressing the importance of group subjectivity and its relationship to the individual, and the second corresponding to the dynamics of the molar and the molecular and the desire that underpins them.

First period: subject groups/subjected groups

From his very earliest texts, Guattari attempted to understand the fascination of fascism. In an essay on group subjectivity he divides collectives into two forms: subject groups and subjected groups. Subject groups are groups that form their own discursive statements; they are fluid in nature and display a high degree of transversality. They are non-hierarchical and are revolutionary in character. We could think here of the various transversal art collectives that we discussed in chapter one, or perhaps the many therapy groups at La Borde that encouraged communication and connectivity. These types of groups attempt to change the world and themselves. They are committed to a cause and often challenge and change the status quo.

Subject groups set their own agendas and create their own identities. However, this often comes at a price, because they are also evanescent, as their fluid and non-hierarchical nature means that they can break apart, imploding in an act of group suicide at any moment. The thing that makes a subject group revolutionary is the very thing that threatens its existence.

We could think here of the many small artistic groups that surrounded the Dadaists of the 1920s and those that sprung up simultaneously in New York, Berlin, Paris and Zurich. None of these groups had a distinct identity or cause. They were, to use Hans Richter's words, more a 'storm that broke over the world of art as war did over nations' (Richter, 1978: 9) These groups were remarkable for their energy and output, sweeping away old conceptions of artistic endeavour and challenging the stuffy atmosphere of the museum and the gallery. But Dada imploded as quickly as it begun, fracturing into numerous other groups and artistic techniques and tendencies (modernism, surrealism, photomontage, cut-up etc.). It was revolutionary and it was nihilistic, and it was precisely this that caused its death.

In marked opposition, subjected groups are those that have become staid and static. Their desires and aspirations are dictated to them by outside forces; they are reactionary; they are reliant on history, tradition and regulation for their homogeneity and they accept repression willingly. They have little transversality and they tend to be inward looking and ward off their own death, both individually and collectively by recourse to cult leaders and father figures. Subjected groups are closed and restrictive; they rely on the construction of outsiders for cohesion and are largely conservative and anxious.

We can see this socio-psychological dynamic fully at play in Nazi propaganda that appeals to both the subjected group's sense of tradition and the rigid paternal figure. The image of Hitler becomes then, not a kind of enigmatic persuader as many propagandists might suggest, but a father figure used to ward off

social anxieties and the fear of collective death. In a famous early example of Hitlerian aggrandising, we see an image of the Führer holding the flag of the National Socialist party whilst behind him stand hundreds of ordinary German soldiers doing the same. The caption reads 'Es lebe Deutschland!' ('Long Live Germany!'). Hitler not only stands at the head of the country's defenders but he dwarfs them in size, towering over them like a giant.

Guattari would suggest that here propaganda serves as a device to ward off the death of a subjected group – in this instance, the German nation – rather than as a conduit of persuasion. The figure of Hitler, for early Guattari was more than a symbol of unity and strength; he spoke to the heart of every German concerned about the economy, worried about the state of the country, anxious about their group identity.

In a similar vein, in 1937 the Nazi party staged an exhibition in Munich consisting of some of the most important avant-garde artists of the 1920s. This exhibition ran for four years and became the most well attended art event in history. The difference with this event, however, was that viewers did not come to admire the art but to condemn it as degenerate and 'un-German'. It was a form of anti-exhibition. Artists such as Marc Chagall and Otto Freudlich were exhibited with details of their cultural and genetic background, and movements such as Dada were pilloried as being contrary to the tradition and classicism of National Socialist party aesthetics. What other proof is needed that fascism fears the subject group because it threatens the status quo by its revolutionary energy?

Instead, Nazi party propaganda relied on consoling images from a mythical past to bring people together and to imbue them with a distinctly molar identity. The German people were happy to engage in this process, caught as they were within the psychological bad faith of the talisman and the leader figure.

Of course, these two types of groups are not mutually exclusive – one can easily turn into the other: a subject group can acquiesce and calcify into a subjected group. Their leaders (once revolutionary

and vital) can turn into meaningless icons that subjugate rather than liberate. Think of the images of Lenin that were used by the Stalinist regime to repress counter-revolutionary forces in Russia; or the images of Che Guevara endlessly reproduced by the Cuban tourist industry linking them to global capitalism fuelled by American exports. Thus subject groups can easily lose their self-made identity. The icons and images that once liberated a whole generation of Punk youths have slowly become used as images to proliferate a global capitalist culture – arguably, the exact opposite of its original intentions. Guattari here is drawing on his Sartrean roots and especially the concept of the 'practico-inert' from his *Critique of Dialectical Reason*.

Subjected groups can also realise their own power and expand beyond their own limited boundaries, transforming themselves into subject groups and releasing their revolutionary potential. This is what happened at La Borde, where patients and doctors employed the tools they had at their disposal (the psychiatric institution, the doctor/patient relationship etc.) to change the status quo from the inside, liberating themselves from the stultifying restrictions of the institution and changing the institution at the same time. This is also the case with movements such as the various anti-capitalist protests of the 1990s and the early 2000s where thousands of ordinary people spontaneously reacted against global capitalism and, later, the imposition of Third World debt. The usual popular idolatry given to modern day icons such as David Bowie and Bob Geldof was utilised to progress a series of agendas that were both localised and global, both concerned with group identity and personal psychology. It has even been suggested that such a coming together constituted the third greatest superpower in the world.

Second period: the age of the anti-Oedipus

Anti-Oedipus was like a violent eruption on the French intellectual scene of the 1960s. It was more than a book; it was

as Perry Anderson states, 'a moment'. Its dense prose was both seductive and maddening and the vastness of its intellectual mandate was breathtaking and confusing in equal measures. It was written against the backdrop of the student protests of 1968 that saw almost the whole of French cultural and working life brought to a standstill in a matter of weeks. It reflected not only the desire to explore new ways of organising philosophy and psychology, but set out to destroy the old ways forever and to bury them under an ever-growing mountain of new concepts and new philosophies. *Anti-Oedipus* was the hot knife that was used to cut out the disease of structuralism and reductivism that had dominated European thought.

One of the major questions at the heart of *Anti-Oedipus* was that of fascism. France, of course, had known its historical form during the war but, for Deleuze and Guattari, it represented a much deeper psychological desire on the part of the individual. Linked to the concepts of subject and subjected groups, but also subtly different, Guattari was about to enter the most important phase of his political critique: the injection of personal desire into the political field.

Based to an extent on the work of erstwhile Freudian, Wilhelm Reich, Deleuze and Guattari suggested that far from being a hierarchical, top-down system of restriction, fascism was instead reflective of the flow of desire within, and from, everyone. It was transversal, both molar (in that it appealed to the national, the cultural and the political) and molecular (in that it involved the movement of desire from the individual to the group and back again). For them, the large political manifestation of historical fascism was merely a molar manifestation, a coming together of many molecular, 'micropolitical' fascisms.

For Deleuze and Guattari, the totalitarian state had no need to persuade entire populations to engage with its fascist ideology because, in essence, we already engage with it on a daily basis: the authority parents have over their families; the historical

dominance of men over women; the well over the sick; the police over the criminal; the teacher over the pupil and so on are all examples of micro-fascist subjugation that come together *en masse* to produce the macro-fascism of the political field. It is impossible, they said, to divorce the psychological from the political, as theorists had done since the times of both Marx and Freud. They were one and the same process. The political was merely a way of directing the desire that occurs on a personal level.

Anti-Oedipus saw the family as the first cell of the fascist regime, the first instrument of control that we are inculcated into and that we rely on throughout our lives. We come to depend on the consoling subjugation that it brings. We gladly enter into its restrictive jaws, allowing it to dictate and direct our desires where it wishes – I will marry the girl/boy of my dreams, settle down and create little fascist cells of my own. The workplace was a mini-occupied territory, with its own hierarchical fascisms. The schoolroom is a microcosmic totalitarian state, and even the superego with all its rules and prohibitions that exist within us is a minute concentration camp: don't do that or you will be sorry, don't rock the boat; don't put up with others who upset the equilibrium. The family, the school, the workplace, and the media are all merely instruments that direct our individual desire, the molar formations. They are social assemblages that trap and control our molecular selves. For Guattari, macro-fascism was merely a quilting point, a coming together of all these different micro-fascisms. It was all the mini issues and repressions that people engage in every day of their lives. It is little wonder then, that they are so willing to go along with its larger political manifestations.

This point is ideally exemplified in Third Reich propaganda that constantly relies on images drawn from a whole variety of different fields. Countless Nazi propaganda posters rely on images of the nuclear family, many draw on images of the workplace (one states 'Let's Build for Hitler!', others show consoling images of

traditional crafts such as the blacksmith, the builder, the carpenter and so on). Others show Nazism as it is connected to physicality (the thread of physical fascism – that you must be tall, blond and muscular to be genetically pure) and some display Nazism as it relates to women, children, hatred of the Jews, Gypsies and so on. The primacy of fascism as a political discourse, its main functional power in the twentieth century, was its ability to knit together and encode all of these separate micropolitical desires into one macropolitical ideology.

This last point is neatly exemplified by the anti-American poster by Leest Storm, which was conceived and published in 1944. This image depicts both macro- and micropolitical concerns: we have the overall symbol of the Kultur-Terror, the social aggregate of Nation and homogenous culture, something that is exemplified by the stars and stripes and the image of the Statue of Liberty in the background. However, this is not Godzilla or Jaws; it is not made up of a single entity or a single anxiety. Instead it is constituted by a whole range of different micropolitical concerns. We see, for example, the desire to curtail rampant sexuality in the form of the rather racy beauty pageant leg; the desire to maintain racial purity in the threatening African-American arms; the desire to maintain civil order with the reference to the ubiquitous American gangster; the desire to maintain economic purity in the form of the Jewish banker who clings on to the bag stuffed with US Dollars; the desire to maintain European cultural purity by the threat posed by jazz records and even the desire to rid society of extremist groups like the Ku Klux Klan and others are all depicted.

As Kristen Williams Backer has pointed out, what Kultur-Terror depicts is the various micropolitical desires that go towards making up the large molar aggregates. This is what forms the basis of fascism, and this, for Deleuze and Guattari, is the way it was able to install itself into the heart of every home and into the minds of every citizen. The monster depicted in Kultur-Terror is

what Deleuze and Guattari refer to in *A Thousand Plateaus* as a war machine, a social assemblage that mobilises every one of the micropolitical desires, and in doing so re-directs the molecular desires of the individual for its own ends. Despite the war machine depicted here being American in nature, this is exactly how Guattari saw fascism working.

Unlike many totalitarian regimes, fascism requires the complicity of the population, and before Deleuze and Guattari injected the concept of individuated desire into the political field, the only way we could explain the process of mass mobilisation was through recourse to ideas of persuasion (through propaganda) or authoritarian fear and oppression. The concept of micropolitics of desire allows us not only to understand areas like propaganda but how we can keep repeating the mistakes of the past. As we shall see in the next part of this book, Felix Guattari assumed that change on a molecular and micropolitical level could bring change on a molar and macropolitical level also. Each of us has the power to change the world, not through tub-thumping and political dogma (Guattari assumed that, like subjected groups, this runs the risk of descending into reactionary anti-revolution like the Stalinism of the 1940s and 50s) but through liberating our molecular flows, and directing energy and desire towards positive ends. In doing so we can resist the repression of micro-fascism whether it relates to one's sexuality, one's body, one's psyche or one's life.

For Deleuze and Guattari, the May 1968 protests were a clear example of how individual molecular desire can be both revolutionary and liberating. The desires of almost an entire population spontaneously collided and formed an unstoppable force that brought the government to its knees: factory workers, students, filmmakers, philosophers, dustmen, intellectuals and so on, were all fuelled by their prospective micropolitical concerns but came together to form a molar subject group. This is the

starting point of *Anti-Oedipus* and its attempt at describing an anti-fascist life. How can we be sure that the spectre of fascism does not raise its ugly head again? It is not achieved by banning propaganda, and not by censoring its speeches, nor is it by flatly refusing to encounter it head on in the political. Instead it is through challenging and dismantling its micro-structures, the structures that we all rely on: the seemingly meaningless and petty restrictions that we all engage with every day. To liberate the world from fascism, you must first liberate yourself. Forget the macropolitical – the micropolitical is where it's at.

Part Two: How to make yourself a war machine

Chapter 4

The machine

What is a machine? For Heidegger it represented the constant process of unfolding technology; for the Futurists it was the symbol of the modern age; for the Dadaists it was the absurd epitome of the First World War. For Marx it was the source of alienation and misery for thousands of factory and agricultural workers; for Walter Benjamin it meant the destruction of artistic aura and for Marshall Mc Luhan it was the means to revolutionise human consciousness through mass communication and widespread typographical homogenisation. Ideas of what a machine is go right to the heart of what it means to be human.

Of course, for the most part philosophy has assumed the machine to be merely that which opposes the organic – the technical and the biological. For the philosopher Henri Bergson, the clear distinction between the mechanical and the natural was the source of both great anxiety and great humour. In his *Laughter: An Essay on the Meaning of the Comic*, for example he describes the mindless repetition of the machine as being one of the bases of classic comedy, as he says:

The attitudes, gestures and movements of the human body are laughable in exact proportion as that body reminds us of a mere machine. (Bergson, 2009: 29)

The machine-like is funny because it is so distinct from the human. Bergson was writing before silent comedians such as Charlie Chaplin and Buster Keaton made full use of the mechanical nature

of comedy in their pratfalls and slapstick, turning themselves into 'mere machines', but this neatly exemplifies what he was alluding to. The machine, then, has been seen as being recognisably un-human, somehow outside of the remit of what we might think of as 'us'. 'He or she is like a machine' we might say to either compliment or condemn, where what we really mean is that they are somehow beneath, beyond or exterior to the complimentary concept of what it means to be human. One feels, emotes, sympathises and decays the other functions and performs soullessly, heartlessly, until it wears out or breaks down. The machine and the human are permanently divided and yet, as Heidegger states, also inextricably linked.

A machinic bestiary

For Guattari, the distinction between the machine and the human was unsatisfactory. In an age where scientific discovery blurs the line between what is made and what is born, what is capable of self-reproduction (autopoiesis) and what depends on others (allopoiesis), the definitions of machine and human need to be re-drawn. The intelligence of machines now outstrips most human beings and they have the capacity to reproduce without our intervention. In fact, now one generation of computers can dutifully design the circuits and diagrams for the next, in an act that is the ultimate in generational suicide – making themselves obsolete for the sake of the future.

Guattari wanted to define machines in terms of what they did, how they functioned, rather than their physical construction or their relationship to the biological. So what do machines do and how do they work? Machines plug into other machines; they form linkages, syntheses and perform a specific function. They are different from a tool such as a hammer, because that is merely an extension of the arm. The machine is both separate and connected, both individual and group (you see where we are going now!).

The machine is not an isolated incidence of technology. It is intimately connected to a whole mechanosphere of similar devices

all performing specific actions. Some are linked physically to others, while others are linked by function alone: the recycling truck collects the newspaper, takes it to the recycling plant, the plant processes it and delivers it to the paper manufacturer who produces the paper and then onto the printer who prints the newspaper and so on. But this is a simplistic view of the machine. It misses the smaller, molecular elements of the process: the recycle truck is not merely a machine, it is itself a mechanosphere, a molar entity of machines and machinic processes: the engine machine turns the axel machine that turns the wheel machine that is connected to the break machine and so on, for as long as you want. Each element of this molar machine, each tiny micromachine, is a partial object that has a function which is both individuated and also linked to the larger assemblage.

Machines are driven by flows, either real or virtual. These can be the oil that passes through them, the petrol that powers them or the product that is made by them. But the flow can also be what we could think of as the will of the machine to keep turning; the desire of each component to connect to its neighbour and to fulfil its mandate in the larger assemblage. The art installations of Jean Tinguely are classic examples of the will of the machine to keep turning. His works look like machines, they function as machines but they produce no product except the kinetic joy of machinic movement. Tinguely's sculptures are composed of the detritus of the twentieth century – wheels, pistons, pulleys, chains, carousel horses, garden gnomes – but they are constructed as giant machines that whir and clank and revolve, celebrating the exuberance of movement. What flows through Tinguely's machines is desire itself, desire to keep moving, desire to connect, to disconnect and to synthesise. The heterogeneity of Tinguely's partial objects, the bits that make his machines is unified only by the desire that flows through them. Objects rid themselves of their intended use value and are instead recycled under different guises: the bicycle wheel becomes part of the moving arm of a

mechanical giant; two steel spoons become the kicking legs of an artificial insect in a fountain in Basel and so on.

Guattari adopted this definition of the machine to counter the traditional philosophical binary of vitalism and mechanism and therefore also to counter some of its manifestation in Freud and Marx. The image of the machine appears in early papers such as 'Machine and Structure' and Deleuze himself attributes its use to Guattari in an interview carried out in 1972, but it is only with *Anti-Oedipus* that it coalesces into a distinct idea. As an idea though, it is a foundational one because, for Guattari, we can all be thought of as machines, or at least machinic assemblages. The mouth is the eating machine; the stomach the digesting machine; the anus the defecating machine; all knitted together by the movement of flows: blood, faeces, semen, tears, sweat etc. Our bodies and our selves are moved by the same will to process and disrupt flows as the sculptures of Jean Tinguely. We are desiring-machines and we produce our own desire.

For Guattari, machines come in a range of different sizes and shapes but each has the same basic characteristics:

1) They connect to and form part of other machines.
2) They process and disrupt flows.
3) They have an overriding organising principle.

This next section will look at three of these machines, each of which gradually increases in size, from the molecular machines of the unconscious to the larger social machines of politics and ideology. Guattari's machinic bestiary allows us also to chart the development of his thought from the early to the middle period, the period in which he attempted to find ways of answering some of the critiques we outlined in the first part of this book.

The desiring machine

Deleuze and Guattari thought the unconscious was a machine. Rather than the theatre of Freudian analysis, where plays and dramas such as *Oedipus* are played out, they saw it as a factory that

produces desire and that attempts to plug itself into a variety of other machines and processes. First, the breast machine of the mother, then the various social machines – the school machine, the capital producing machine of the workplace, then the drug machine or the language machine. We desire to connect ourselves to our partners, thinking that we cannot be complete without them. We become sockets and plugs, coupling in the human and the machinic sense. However, desire for Deleuze and Guattari refers not to sexuality *per se* but to the will of the machine to connect to others and to facilitate the flows that run through it. It is linked to sexual desire and certainly covers, but is not limited to, it. Their form of desire extends far further into our unconscious and our very natures. We might think of it as the Nietzschian 'will to power' or the pre-subjective libido of Freud.

We each have a series of desiring machines inside our heads, what is yours? What is your thing? What links your desiring machines to others? Guattari formulated the idea of the machinic unconscious at La Borde where he saw the mechanical way that schizophrenic patients related to themselves and to the world around them. Some, like Daniel Paul Schreber complained that the various parts of his body were rebelling against him. Others, like Antonin Artaud thought that his body was ridding itself of its organs. Psychotics, thought Guattari, exist outside of the generally restrictive morality of the Oedipus complex. Psychoanalysis cannot deal with them, but they expose the processes of desire and desiring-production for all to see.

The notion of the desiring machine enabled Guattari to conceive of an unconscious without relying on lack. As we said in the first chapter, this reliance on a central absence, a foundational missing element, is present in both Freud and Lacan but it creates, as Deleuze and Guattari state, an unconscious that is always depressive, always neurotic and always constructed around a primal loss. Desiring-production, however, is expansive, exuberant. It revels in desire, swims in it, sees it as a positive and

revolutionary flow that emanates from our unconscious and passes through us in an attempt to connect us to the outside.

The cartoonist Heath Robinson created desiring machines, machines that both ran and broke down in equal measure and that connected to others in an endless cycle of connectivity and synthesis. His fantastic contraptions facilitate the desires of the mind that sits in the middle of them: the desire to eat, to wake up, to carry out tasks. To us, the viewer, the delight is in the sheer sense of connectivity between the various elements of the assemblage.

In 2003 the motor company Honda produced the short film *The Cog* to advertise their new car, the 'Accord'. The advert featured a Heath Robinson-type assemblage consisting of various car parts linked together to form a continuous flow of movement, from the wiping of windscreen wipers on the floor to the kinetic movement of the stereo speakers. The tag line to the commercial was 'Isn't it nice when things just work?' Of course, what they meant was 'Isn't it nice when things just flow?'

What is more interesting is that a supplementary film was made that detailed the trials and tribulations of the director and the crew trying to get things to work. Hour after hour, month after month was spent trying to get each of the parts joined up together because machines, as we all know, are as likely to break down as they are to continue working. This is also the same with desiring machines. They cut off flows as much as they allow them, going wrong, and breaking down. Flows are allowed to disconnect and to form other, unheard of connections. The desire of the fetishist to connect to a partner is redirected to an object – a shoe, a pair of high heels, a gas mask, a stocking top – the desire to connect to those around us is directed at the movie screen, the internet, the characters in a soap opera and so on. We produce desire and we guide and direct it through other machines via a series of connective syntheses and disjunctions. The desire to connect is at the heart of Guattari's materialist psychiatry (what he termed his schizoanalysis), which traces this process and attempts

to cartographically map the flows as they appear. Don't try to interpret the psychotic, he says, like Freud; it is much better to understand where their desire is taking them. Make a map of their desiring machines.

The technological and the social machine

If you are reading this in 100 years time, the chances are you are doing so on an electronic book (I am assuming here that some catastrophe has not befallen planet Earth and you are not, in fact, reading this by candlelight). The ebook, iPad, iPod, laptop, netbook and touchpad are all examples of technological machines that form assemblages with the desiring machines that are us. Assemblages are made from heterogeneous elements. They come together and fall apart just as easily, but have a life and a purpose of their own.

The human and the technological machine do not merely come together. One is not simply an extension of the other. Instead they form a rhizome, a machinic assemblage that is both temporary and loosely bonded. Consider the iPhone, an extraordinarily technological device and one that is more a way of life than a simple tool. The user interacts with it physically, placing their ear to the speaker, and their mouth to the microphone, swiping its surface with their fingers, there is a becoming of sorts, a sharing of DNA at a molecular level. Mobile phones have not only been utilised by humans, they have altered our behaviour. If you walk along any street in the twenty-first century you are guaranteed to see the familiar gait of the phone user or texter, because technology changes the very way we use our bodies.

However, the iPhone is more than an object and it is more than a mere machine. It represents a wealth of different ideas and concepts, desires and wishes. It represents a coming together of internet and mobile phone technologies, an end to the idea of static internet connectivity. Its design was one of the first popular instances of touchpad technology and in this regard forms a line

of flight from existing telecommunications. It is also symbolic of Western capitalism, of the desire for ownership, of the zeitgeist of the global. We become an assemblage of communication with our mobile phones. Our thumb becomes a texting-machine with the iPhone's touchpad, altering its original biological function and entering in a process of mutual becoming.

The technological machine is, however, inevitably plugged into the various social machines: the economic circuits, the cultural zeitgeist, the systems of social organisation, the family, the education system and so on. Social machines are like technological and desiring machines, only they consist of large processes and sociological assemblages. Foucault studied these when he looked at the prison, the hospital and the asylum. The social machine is full of technical machines. Take the hospital: it is itself a technology and we are plugged into it from the moment we are born. Usually it is the last machine that we connect with before we die. Social machines shape us as much as we shape them.

Machines upon machines, pulling into each other, pulling apart from each other. This is the idea that opposes the vitalism/mechanism binary – a machine is not an inanimate thing. It is a desire for connection and a director of flows. It is vitalism, it is mechanistic.

Abstract machines

For Guattari, the psychology of the desiring machine and the sociology of the social machine come together under the umbrella of the abstract machine. The abstract machine appears throughout *A Thousand Plateaus* and is one of Deleuze and Guattari's most nebulous ideas. It is deliberately vague and unformed, and this is perhaps, one of its main strengths.

The abstract machine can be thought of in the same way as Foucault's concept of the 'enunciative modalities' he describes in *The Archaeology of Knowledge* as: 'The law operating behind

...diverse statements, and the place from which they come' (Foucault, 2002: 55).

In their characteristically dense language, Deleuze and Guattari describe the abstract machine as carving out territories and planes on what they term the 'body without organs', the part-theoretical, part-actual proto-existence that underlines their conception of flows and desire. The body without organs is the undifferentiated flux out of which forms and territories are made, and the abstract machine is the diagrammatic plan that provides their basis. However, abstract machines are productive rather than merely descriptive. They carve out shapes, forms, existences; they are experimental and yet do not exist in the physical sense, only as a series of actions.

Imagine the diagram, it can do two things: either it can describe something that already exists (like the London underground map) or it can provide a blueprint of something that is about to exist or perhaps never will, like a manifesto or the experimental plans for a new piece of technology. The first creates no new territory, it is merely a figurative rendering of a concrete form, but the second describes and creates potential. It encourages becoming and brings together disparate elements, ensuring the abstract becomes the actual. The second type of diagram then cannot be divorced from the thing that it describes, and more importantly, cannot be divorced from the action of creating the thing. It knits together all the elements of the machinic assemblage – the desiring machine, the social machine and the technological machine.

As we have already seen, Dada was a movement without a centre. It consisted of a series of artistic acts and statements that came together under one roof. You cannot touch Dada, you cannot smell Dada, Dada is merely an abstract notion. Yet it is productive, it produces and it draws a number of machinic elements together. It is the abstract machine that gives resonance and direction to the desiring machines of the painters, the social machines of their

backgrounds, the pulsating force behind the movement, in each of its meanings.

In the work of Jean Tinguely, the artist's own abstract machine knits together the disparate elements that make the sculpture. Partial objects such as spoons, carousel horses or cartwheels are scooped up in the abstract machine and their function in the social machine. A wheel no longer functions as a method of getting from A to B. Instead it is the shoulder blade of a monster, the eyes of a giant or some other non-intended function. Nothing has changed in terms of the structure of the object – it is still a wheel – but its relationship to the abstract machine has changed, it has been inculcated into another – the Tinguely-machine.

We saw in the last chapter how the fascist abstract machine mangled the desire of the German people and re-coded their connectivity, re-routing it for its own ends. Propaganda uses many of the same images: happy families, strong workers and important leaders to name a few. But the abstract machine changes with each political regime. The fascist abstract machine fights the communist abstract machine, the Western liberal abstract machine fights the Muslim abstract machine and so on. All machines desire connection and disconnection with other machines – machine upon machine, desire upon desire.

Blood machines

The contemporary horror film is full of machines. Movies like *Saw*, *Hostel*, *Frontiers* and *Texas Chainsaw Massacre* create blood machines, pain machines and death machines. They are a mechanosphere in themselves and some of their terror arises out of the unnatural way that machines are employed. For example, when the chainsaw is removed from the abstract machine of agriculture and transplanted into a place it does not belong, it becomes a terror machine. It is made all the more fearful by its familiarity and the fact that it seems out of place. Indeed, what is Leatherface but a pain and death machine who has become one with his chainsaw?

The larger social machine of the family has created him, tailored and botched his desire, but it is the technological machine of the chainsaw that gives him his special terror. How much less disturbing would he be if he used a knife, or his hands to kill? He is man and machine existing as a machinic assemblage.

We see the same dynamic with the two horror films in Eli Roth's recent *Hostel* series. The particular nature of the terror of these films seems to arise out of the employment of everyday machines to cause pain, suffering and death in the young people who are taken to the Elite Hunting warehouse. As the camera pans over the table of weapons to be used in the torture, the viewer is taken by the fact that they seem ordinary and unremarkable: there is the knife, the drill, the wire cutters, the chainsaw and the other machines of everyday. However, all of these objects are taken from their usual context and placed in another, altogether more disturbing, one.

The seven films of the *Saw* series also exemplify the assemblage of human and machine, only this time it is the victim who forms the major biological component. John Kramer is the abstract machine that knits all of the elements together: the desiring machine of the victim, the technological blood machine, the social machine of ethics, class and interpersonal relationships. We cannot separate any of these machines. They produce and are facilitated by the constant flows that ensure that they run: blood, sweat, oil, petrol, pain, flesh. The victims of John Kramer are desiring machines in themselves but they are locked into a larger machinic process and become an assemblage – their flesh and the metal combining to produce the death machine. And it is a death machine that, like all machines, is both terrifying and transformative.

Machines walk through the work of Felix Guattari. They add both consistency and fluidity to his work, allowing him to unite the usually separated fields of Freud and Marx – the political and the psychological. *Anti-Oedipus* begins with a print of Richard

Lindner's 'Boy with Machine', a painting that depicts a large, overweight schoolboy seemingly plugged into a complex but arcane piece of technology. The boy is overstuffed, fat, as if being fed from one of the tubes of the machine that stands behind him. The point about this picture, however, is that both boy and technology form one machine. They are inseparable from each other, differing only in speed and intensity. The boy is an eating machine, the technology perhaps a feeding machine. Like the torturers in *Hostel* or Leatherface, the boy has formed an assemblage with the machine, caused by the flow of desire. He has connected with it and revels in it, until he forms a new connection somewhere else. Machines are everywhere, in and outside of us, and serve to direct and guide flows. Whether they are the sculptures of Jean Tinguely or the blood machines of John Kramer, machines cannot be separated from the desiring machines of the human unconscious. Better just sit back, and watch them work.

Chapter 5

Schizoanalysis

How do we understand these machines? How do we make sense of the connections between an individual's desiring-production and the social assemblages? And what is the difference between the workings of abstract machines and the flows that are produced in the unconscious? For Guattari, psychoanalysis fails to take into account the constructive nature of this process as it tries to reduce everything to interpretation and theatre: you are like Oedipus; you are like Hamlet; you are like your mother and you are like your father. Psychoanalysis, as we saw in the first chapter is also based on lack: you desire that which you cannot have. The best you can hope for is a substitute, a fetish, something that will tide you over. Psychoanalysis also works through explanation and interpretation. The analyst is the clinical version of the art critic, someone with magical powers, who tells us what to think – this is the meaning of this painting or image, this is the meaning of your dream. Psychoanalysis relies on the all powerful figure of the analyst, the Freud figure, the Lacan figure, the Klein figure, it is all the same. Felix Guattari, it is safe to say, had issues with psychoanalysis.

The answer that Deleuze and Guattari offer to many of these issues in *Anti-Oedipus* is schizoanalysis. Schizoanalysis was inextricably linked to the wider social and political field of the late 1960s. Deleuze and Guattari conceived it in the shadow of the student protests of 1968, where figures of authority from de Gaulle to Freud were crumbling and losing their validity. All over the country people were following their desiring-production,

allowing it to spill over into the political, using it to inform both their individuated and collective subjectivities, and to scare the government to death! On 13 May 1968 a million people marched in Paris. Between 25 and 28 May the country was brought to a standstill by flash strikes that covered all areas of public life, and on 29 May, President de Gulle fled the capital to his retreat in Baden Baden. Revolution was in the air.

It is no coincidence that many of the most important theories to come out of the May 1968 protests were prefixed with either 'post' or 'de': *post*colonialism, *post*structuralism, *post*modernism, *de*construction, *post*feminism and so on. Each of these terms signalled something more than a new theory or perspective. They signalled that the world was changing and that things would never be the same again. Schizoanalysis came out of this and also sought to understand it. It was as if Guattari had been waiting for this moment to fully demonstrate the power of both the group and the individual, as if the theories that he had been working on at La Borde, both in terms of patients and in terms of politics were being realised in the streets of Paris. Desire was everywhere and it threatened the status quo.

So schizoanalysis, as we shall see here, is both a clinical and a critical tool, and despite the doubts of some Deleuzians, can be used to understand cinema, art and the whole of visual culture. It should be said, however, that schizoanalysis is a process rather than a perspective. It tries to disrupt the usual patterns of criticism by burrowing under their traditionally accepted terms, as it tries to uncover the connections of desiring-production, to trace the lines of escape that the unconscious makes and to discern and highlight the assemblages that are made between subject and world. As Deleuze and Guattari themselves state:

The first positive task (of schizoanalysis) consists of discovering in a subject that nature, the formation of the function of his desiring-machines, independently of any interpretations ... The schizoanalyst is a mechanic, and schizoanalysis is solely functional. (Guattari, 1996: 77)

What does this mean: 'independently of any interpretations'? Psychoanalysis, much less how it is used in art criticism, surely is based on such methodology, in the imperative to explain things. For Guattari, this act merely reduces the complexity (we might even dare to say the beauty) of the unconscious and its productive efforts. Better, say Deleuze and Guattari, to concentrate on how something works, how it functions, how the parts fit together, how the flows are directed and how it seeks to break its own boundaries and capture the intensity of the creative moment. Schizoanalysis is a process of map drawing rather than map reading. It encourages us to trace the eruptions of desire and to view the artist, the work and the viewer not as three separate identities but as parts of an assemblage that is the 'art-machine' that we plug into and out of at will, experiencing its flows in the process.

In the last section of *Anti-Oedipus* Deleuze and Guattari outline three main tasks of schizoanalysis, one negative and two positive. The first consists of the kinds of destructive thinking that we outlined in the first section of this book. For Guattari, we have to break down before we can rebuild – the edifices of psychoanalysis, the trappings of Oedipal triangulation, the straightjacket of the family and so on. The second and third tasks (the first and second positive tasks) consist of first uncovering and identifying the desiring-production of the individual (the patient, or conversely the artist or writer) and, second, in understanding how these are invested directly into the social field. Schizoanalysis looks at how desire is libidinally invested into the social, how it can disrupt the working of the wider society. It sees how it connects with the social machines and the institutions, how it is directed by technological and abstract machines of style and artistic oeuvre. The Warhol machine produces one form of art, the Manet machine another, the Emin machine yet another.

It must be said, however, that Deleuze and Guattari very rarely use schizoanalysis to look at works of art or visual culture. Their book *Kafka: Toward a Minor Literature* is an almost perfect

example of how it can be used to understand literary texts, but what I will present here is a practical interpretation of its use in art criticism. The work of philosophy, say Deleuze and Guattari, is to create concepts and we could say the same for art and film theory. Concepts, however, are ever-changing; they are processual, never staying the same. Schizoanalysis is no different. It follows the lines of flight that the unconscious puts out, attempting to trace the productions of the desiring machine and tries to discern points of connectivity and synthesis. However, ultimately it is a flexible conceptual tool that allows us to discern how Guattarian concepts can be used to understand not only the creative process but the act of viewing and experiencing an artwork.

The suicided man

Antonin Artaud's essay, 'Van Gogh: The Man Suicided by Society' is a coming together of two forms of psychosis: van Gogh's paranoia and Artaud's schizophrenia. Throughout most of his life, van Gogh suffered from poor mental health. Temporal lobe epilepsy left him open to attacks of depression and seizures, and many believe that he was born with severe brain lesions that would have facilitated the onset of his instability. Thomas Courtney Lee has even suggested that the propensity for the colour yellow in van Gogh's later work can be partly attributed to the digitalis that was prescribed by contemporary doctors for epilepsy (digitalis poisoning results in the visual field being turned yellow in a small percentage of patients). Lee posits that we can discern the mental state of van Gogh by his colour palette. The blacks and browns of his earlier depressive work change in the later paintings to a vivid yellow, as psychosis gradually takes hold in Arles during the 1888s, which eventually results in his suicide.

Artaud, however, thinks differently. For him, van Gogh's paintings were not reflections of his mental instability but explosions of energy from a sensibility that society could barely contain, as he says:

No, van Gogh was not mad, but his paintings were wildfire, atomic bombs, whose angle of vision, compared to all other paintings at the time, would have been capable of seriously upsetting the larval conformity of the Second Empire bourgeoisie … (Artaud, 1965: 136)

What was it that Artaud saw in van Gogh's paintings that assured him of their revolutionary force? What was it that chimed with his own particular form of psychosis? I would suggest that only schizoanalysis can tell us, based as it is in the study of the psychotic rather than the neurotic, and in the machinic rather than the interpretive.

Artaud recognised that van Gogh's paintings resonate with energy, that they seem to be breaking apart at the seams, bursting through the canvas even. The brush and pencil strokes of van Gogh depict a world, as Artaud says, that seems to be 'in the throes of convulsions'. Suns do not merely exist as astral bodies but as swirling masses of energy that send out concentric circles of yellow and orange. Bodies are both solid and fluid; fingers stretch out, flowers seem strangely sentient. This shimmering seems to affect everything in van Gogh's world, from the walls of his room at Arles, to the leaves of the tree and the floorboards on which stand the peasant's chair – everything is in constant movement and flow. The early work of the 1880s reflects van Gogh's interest in Dutch masters and their reliance on visual acuity. The forms are clear and molar, the colours dark but realistic – the later fluidity has yet to take a hold.

By 1888 van Gogh was painting in the short strokes that would come to dominate his style until the end of his life. In some paintings like the 1890 work 'Asylum Garden' (Field of Grass with Butterflies) the brushstrokes would take over completely as if the intensity of the movement of the foliage had overtaken the imperative to reflect reality. For van Gogh, in this period, intensity was everything. Consider his painting of Charles Elzeard Trabuc, the head warden at the Saint Remy asylum. The brushstrokes that fill the warder's jacket are like lines of flight that threaten to turn solid cloth into a fluid surface of movement. The strokes remind

the viewer of a river, flowing over the bottom half of the painting, constantly challenging the outline of the sitter.

The line itself is something that is continually deterritorialised in van Gogh. The outline of the figure of the warder is constantly threatened by the more unruly, unformed lines that constitute the painter's method of colourisation. But the line in van Gogh is never simple; it is never a case of joining two entities together. For every molar one there is also a molecular one. For every line that pulls shapes and forms together, there are others threatening to blow things apart. Such lines, in Deleuze and Guattari are termed the 'line of flight', or the 'line of escape'. These are shoots of intensity and energy that are put out by the desiring-unconscious that disrupt the molar constructs of the social and political self. The line of flight is a molecular movement, an attempt at becoming, a sharing of two genetic codes. It is schizoanalysis' task to trace these lines and to chart the force that they represent. The line of flight is a singular occurrence but it is also part of a multiplicity. The schizophrenic constantly puts out such things, forever trying to break the molarity that restricts them. For example, Lacan saw the glossolalia of the psychotic, the endless stream of nonsensical words they produce, as symptomatic of the failure of the symbolic chain, what he termed 'foreclosure'. But Guattari saw it as a constant search for linguistic escape, putting out language-based feelers and simultaneously disrupting the structure of syntax. Artaud's infamous radio play *To Be Done With the Judgement of God* is a perfect example of these linguistic lines as he experiments with language and poetry, flirting with that which is understandable and coherent.

The same of course can be said of van Gogh's later work that shows an increasing desire to break free from the bounds of traditional visual culture. We see in the figures from the late 1880s an increasing tension between the dark black molar outline and the more fluid inner movement of the brushstrokes and the hatching. It is as if van Gogh was depicting the flow of intensity between molarity and molecularity. The line becomes ever more

deterritorialised, ever freer as his psychosis increases and his experience of the asylum at Saint Remy becomes ever more intense.

In the later work we also see a growing melancholy, with the portrait of Doctor Gachet being a case in point. Not only is the dour face of the doctor painted with a sympathy that is, as has been suggested, reflective of van Gogh's connection to his subject, but the palette consists of dark blues and greens. The skin tones are now yellow and pale and the features of the sitter are ringed with lines that act as both outline and shade. The painting becomes more difficult to discern psychoanalytically. It is hard to pinpoint the semiotic meaning in the wavy lines of the painting's background, and the critical tools of hermeneutic understanding are no longer as useful as they might be to interrogate the mechanisms of van Gogh's work. What we witness in this painting is blackness, sadness. It is as if meaning has been sucked into the dark paint like light into a black hole. Deleuze and Guattari talk of painters as 'presenters' and the 'inventors and creators of affects', they capture feeling in their paint and we connect to it on a subcognitive level that elides understanding.

2. Vincent van Gogh, *Portrait of Dr Gachet* (1890), oil on canvas.

We have to be careful here not to reduce van Gogh's motifs to the comforting but restrictive tropes of psychoanalysis. Schizoanalysis is the study of flows and desire, not the return of the repressed or, as Deleuze and Guattari were found of saying, the 'mummy-daddy-me' relationship of Oedipus.

The tension of the line in van Gogh, between the thick outer molar and the more molecular fluid inner is the object of schizoanalysis but so is the background, with its tensions and its intensities. Backgrounds, in van Gogh's later portraits achieve an almost organic quality. They are as important as the figures and retain as much intensity. The blues in the portrait of Doctor Gachet match the various shades of his jacket – the light and dark patches on his lapel and shoulder melt into the surface that he sits in front of. The various elements of the painting represent an assemblage of sorts, not merely different parts of the same thing but partial objects of a machine: the foxglove on the table in front of Gachet, the books, the jacket and the background are all fluid elements of the same molecular image. Each feeds into the next, and each provides a conduit for the desire of van Gogh and his viewer.

The interconnected planes of the molar and the molecular are, as we have seen, a foundational stone of Guattarian philosophy. Studying the way they interact is integral to the working of schizoanalysis. As we can see, this is much more a question of mechanics than interpretation and the process is one of map drawing rather than map reading. The schizoanalyst follows threads and sees where they lead, but does not look for answers or foundations, trying instead to detect patterns, escape lines and series of intensity.

The portrait of Doctor Gachet also, as many commentators have suggested represents a form of assemblage between painter and subject, a becoming between van Gogh and his doctor, as Judy Sund observes:

Probably because he perceived Gachet as a soulmate of sorts who could truly understand and appreciate it, van Gogh's portrait of the doctor is much more complex than most of the portraits he made, a tour de force with multiple references that seem to be both geared to the sitter and self referential – a dualism elucidated by van Gogh's conviction that Gachet was 'something like another brother, so much do we resemble each other physically and also mentally.' (Sund, 2000: 221)

Here van Gogh joins with his subject, becoming one entity. Deleuze and Guattari suggest this also occurs with other images, most notably, the sunflower whose head dips and bends like Gachet's and whose lines are, again, both territorialising (the straight line in the background, for example) and deterritorialising (the wavy lines of the flowers, the seeds on the sunflowers). In *What is Philosophy?* Deleuze and Guattari offer the enigmatic thought that van Gogh enters into a molecular relationship with the sunflower, as if their shared desire is conjoined and their identities merged. For Guattari, this is more than mere rhetoric. The sunflowers are the machine that joins artist and viewer, linking up the desires of each and directing the intensity of the artistic experience. This is the specificity of art as a discipline. If philosophy is concerned with the concept and science the percept, then true art deals with affect, with the inexpressible and uncontainable feeling of the aesthetic experience. Later in his life, as we shall see, Guattari becomes more and more convinced that this affect held the key to social revolution, that to feel inevitably meant to rebel.

Let us conclude this schizoanalysis of van Gogh with a consideration of his work, 'The Starry Night', painted in 1889. 'The Starry Night' has, like many of van Gogh's works, been interpreted in terms of its religious and biblical importance. Kathleen Powers Erickson, for example, calls it

a visionary masterpiece, recounting the story of van Gogh's ultimate triumph over suffering, and exalting his desire for mystical union with the divine (Powers Erickson, 1998: 170).

This painting, however, is also a perfect example of how schizoanalysis can be used to understand the relationship we have to images. What we can draw from this painting is not so much its semiotic meaning (what the elements in it mean or refer to) but what it does. The sky above the town is in constant movement. It could be described (using a word that became increasingly important to Guattari) as 'fractal': the swirls of the astral bodies

are themselves made up of swirls of paint and brushstrokes, the curlicues of blue and white seem to form a double helix in the centre of the picture that forms a fold, the inner becoming the outer and so on. The painting itself can be seen to be on four planes that produce an ever increasing sense of deterritorialisation: the bottom plane presents a town (that some have suggested is Saint Remy) with its angular houses and central spire – this is the social, the molar. Notice how the sides of the houses are depicted in blocks of colour; we see none of the cross hatching that characterises the sky. The second plane is made up of the hills behind the town, which begin to disrupt the sanctity of form, as if van Gogh's visual sense was letting go of the molar and becoming molecularised.

The third plane presents the swirling of the astral bodies. The brushstrokes become more and more flecked as form and line become shattered and broken. The circles that constitute the stars shimmer with intensity and the desire of the artist is unleashed, spilling out over the canvas. The last plane is that of the suns and the circular stars that seem to pull in the brush strokes around them like a planetary orbit. The elements of the painting are the line and the circle, both of which enter into a relationship with each other, forever deterritorialising and then reterritorialising, creating and shaping new ground.

Viewed in this way, van Gogh's paintings are not so much products of an unstable mind, but are an outcome of desiring-production whose flows are directed by machinic elements, such as the sun and the line. Antonin Artaud was an important figure to Guattari, not only because he lent him phrases such as the 'body without organs' and the 'body in pieces', but because he exemplified the revolutionary principle of schizophrenia. This is, in essence, what his essay on van Gogh seeks to trace. For Artaud, van Gogh was a sensibility in constant movement, forever trying to unleash his desire, to skirt on the edge of life and existence. It was society, with its sense of order, its rules, regulations, morality and norms that killed van Gogh, not the bullet that buried itself in

his flesh. The mechanics of his paintings, the way they are constructed, the tracing of movement within them, the choice of colour, the ways of capturing intensity, can all be seen as a direct outcome of the bourgeois society that attempted to constrain and restrict him. Like the art therapy that was carried out at La Borde, van Gogh's work is more than a way of working through issues. In fact, this is the last thing that would be needed. It is a method of revealing the inherent tensions between the artist's desiring-production and the constrictions of the social.

Schizoanalysis has been employed in recent years to look at visual culture, most notably cinema. Ian Buchanan and Patricia MacCormack's anthology of essays, *Deleuze and the Schizoanalysis of Cinema* comes close to providing us with a set of critical and conceptual tools that can be used as a basis for relating these kinds of ideas to film theory. The authors employ the same kind of critical ideas that we have used here: discovering the materiality of the image, relating the planes of the molecular and the molar, and tracing the ways in which desire undoes the fixity of the artist's subjectivity. Overall, they suggest that the work of art stands as an assemblage that produces the aesthetic affect, inextricably binding the artist (or in this case the director) to the viewer in a process of meaning-making.

However, this collection comes from a mainly Deleuzian perspective. It tries to reconcile schizoanalysis with Deleuze's books on cinema and his monograph on Francis Bacon, but sadly some of their uses of schizoanalysis seem forced and unformed. In order to really understand how it works, we have to relate it to Guattari's work at La Borde by using his concept of transversality, and his conviction of the machinic nature of the unconscious. When this is considered, schizoanalysis presents itself as a real alternative to psychoanalysis. What began as an answer to the problems of institutional therapy, ultimately manifests itself as a way of understanding a great deal of visual culture.

Chapter 6

Faciality

Regarding the face

How well do you know your face? How often have you seen it in the mirror, touched it, stroked it, noticed it in the window of a shop or seen it reflected in a loved one's eyes? Somehow we think of our faces as being 'us'. Much more than our feet or our arms, our face seems to define who we are. It is inextricably linked to our sense of self and to our own personal identities. The face consists of a number of basic elements and yet they are endlessly rearranged to form an infinite number of variations with an infinite number of looks. With perhaps the exception of identical twins, there are as many faces as there are people that have ever been born.

And yet, our faces are also a major way in which we communicate with the world. Language is inextricably linked to its expressions, and people 'read' our facial language as much as they listen to the words that we say or the non-linguistic sounds that we make. Our face underlines and exposes our thoughts, sometimes before we are even conscious of them, and often gives us away when we want to keep things hidden from others. The face then, is a source of identity and a tool of communication.

This dual relation, between signification and subjectivisation, is at the heart of one of Deleuze and Guattari's most complex and frustrating concepts, 'faciality'. Faciality appears in *A Thousand Plateaus*, in 'Plateau 7: Year Zero' but resonates throughout the text and was mentioned in numerous other essays by both men throughout their lives. Guattari deals with this concept most

specifically in the papers 'Concrete Machines', 'The Architectural Machines of Shin Takamatsu' and an untranslated essay on the Japanese photographer Keiichi Tahara. Faciality is an aesthetic concept, in that it has been used to look at the representation of faces in art and photography. But it is also a political notion that has been employed by Guattari to delineate a socio-cultural zeitgeist and a regime of political enunciation. The face, as it appears in Deleuze and Guattari is more than a collection of sense organs, it is the point at which our inner intractable selves meet the social world of others and, in this, it is a powerful concept indeed.

The first thing that we need to say about faciality is that it does not merely refer to something that looks like a face (something with a pair of eyes, a nose, a mouth, cheeks and so on). For Guattari, the face should be considered in terms of what it does, what it represents conceptually and what it is a blueprint for, rather than how it appears physically or how it has evolved. They begin their chapter on the face by reducing its constituents to two basic elements. Faces, they say consist of a white wall and a black hole, a surface upon which signification is projected (and supposedly read) and a black hole into which meaning disappears and refuses to be reflected. This binary is the basis of faciality and reappears in various guises throughout *A Thousand Plateaus*, combining the usually disparate and unconnected realms of semiotics and ontology – signs and the sense of the self.

This basic schema is somewhat like Slavoj Žižek's reading of the concluding scene of the Charlie Chaplin film *City Lights* that begins his book *Enjoy Your Symptom!: Jacques Lacan in Hollywood and Out*. If you remember, *City Lights* ends with a close-up of Chaplin's face as the girl of his dreams, who was previously blind, looks upon the little tramp for the first time after having her sight restored. Much has been made of Chaplin's look here and its relation to the line that the girl says. In an obviously ambiguous touch, she declares (through the power of the intertitle) 'Yes, I can see him now'. As Žižek

rightly points out, the key to this scene is in the lack of fixed meaning associated with the written language. We are not sure if the girl means 'Yes, I see him now and isn't he wonderful!' or 'Oh God, yes I see him now, he is such a tramp!' The beauty of silent film is that, we, as an audience, are left to decide for ourselves which it is. In the rather more closed semiotics of the talkie, the director, actor and the sound recordist tend to make these decisions for us.

However, what this scene also highlights is the relationship between the white wall and the black hole of faciality. Chaplin's face is nothing if not a white surface upon which we can project our own meaning. We see in his frozen expression at the end of the film, everything from hope to love, fear to excitement and trepidation to longing. His face at this point represents a clear example of the screen upon a screen. It maybe projected upon an actual cinema screen but is itself a surface of sorts (or a wall) upon which the audience projects its own meanings and significance. We read into the blankness of Chaplin's face whatever we want, whatever desire we may have. Conversely, it is also a screen that Chaplin himself projects onto from his own subjective perspective, he projects to the world what he sees fit and we project onto him what we do. Screens within screens, white walls upon white walls.

However, Guattari is no simple behaviourist. It is not merely a case of saying that the face is a form of blank canvas that passively accepts the information that is projected onto it, like the Kuleshov experiments that explored the syntagmatic nature of film and facial expression. The beauty of Chaplin's final image in *City Lights* is the indeterminate area that exists within it, the black hole that destroys the simple relationship between signifier and signified and it is that which disrupts the homogeneity of the white wall semiotic. It is this lack of closure that forms the tramp's own subjectivity. His identity ultimately sets up our relationship to him as a person, a human being with thoughts that we can never completely access. The face has become deterritorialised from the head and the rest of the body. It has

taken on a vital role in the world beyond the individual flesh and extends the corporeal into the symbolic and the semiotic.

So it is this dual process then, the significance of the white wall and the subjectivisation of the black hole that forms the basis of the face, say Deleuze and Guattari. Faciality is the extent that this occurs in situations unrelated to the actual visage itself. They state, for example, that a landscape can display traits of faciality. Guattari, as we shall see, used the concept to examine the architectural work of Shin Takamatsu, and even used it to study modern artists such as Mondrian, whose paintings offer no recognisable faces whatsoever, but still contain the basic binary mechanism of signification and subjectivisation. The important thing, again, is that Guattari and Deleuze see the face as a machine consisting of two interlinked and enchained parts – the white wall and the black hole. It is this that determines

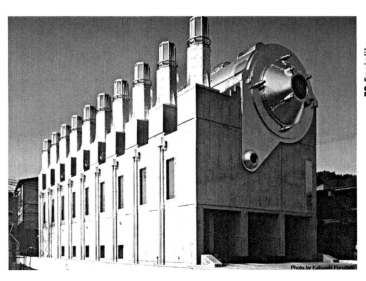

3. Shin Takamatsu, *The Ark Building* (1982).

faciality, not the physical resemblance to a pair of eyes, a mouth, a nose and two cheeks.

Guattari's essay on the Japanese architect Shin Takamatsu and in particular his design for the ARK dental clinic in Tokyo, is an ideal example of the way that faciality can be applied to the arts. Takamatsu's building represents a becoming between the clinic and the railway that stands near it. It looks like a giant toy train, and this is some of its joy and some of its aesthetic sense. The facade of the building both pays homage to the railway and is also a way of generating and reflecting the modern Japanese sensibility. The ARK building with its large plain sides and its obvious black hole-like eye in front reflects both of the factors in faciality and, asserts Guattari, provides the skyline of Tokyo with an aesthetic singularity that is neither postmodern nor modernist. For Guattari, the work of Takamatsu acts like a face, reflecting and shaping the subjectivity of the surrounding population. This creates what he calls 'a becoming-vegetal', a becoming-organic of the building, sending out its shoots and re-creating itself in those that view it. The building is like a rhizome, forming relationships and bodies with those that surround it.

Think of Antony Gormley's celebrated 'Angel of the North' sculpture. In the few short years since its inception, this singular artwork has become a part of the subjectivity of the North of England. We could say that the North East's identity has been inextricably shaped by the mass of rusting iron and steel – although of course it has no face. The ARK building is the same. For Guattari, it represents a machine for the continued creation of Japanese singularity. As a building it was both popular and well used, blurring the dividing line between practical considerations and aesthetics, art and architecture.

There is that eye though, the void in the face that seems to look towards the future, not reflecting but creating. It is an area of indetermination that elides meaning. What is that strange

black hole in the building? Is it a window? An engine? A vent? It is more importantly that which elides signification. It is that which swallows up meaning. It is the black hole on the white wall that prompts Guattari to write:

The architect Shin Takamatsu's ARK dental clinic, built in 1982, is an enormous concrete locomotive planted in Kyoto, an introverted and powerful immobile machine. This building has disturbed the field of architecture just as much as the machinism of Le Corbusier did in its day. To interpret such architecture with metaphors or confine it with all the other semiotico-linguistic instruments is no more appropriate for deciphering Shin Takamatsu's creations than it was for those of Le Corbusier. (Guattari, 1994)

For Guattari, the ARK dental clinic was more than a building, it was a point of resistance. Caught between the modernism of Le Corbusier and the postmodernism of Las Vegas, it represents a way out of the binary of inside and outside, of environment and self. Both come together under its faintly absurd, comical and child-like form. If modernism can be characterised by Le Corbusier's insistence on architectural form's sympathy with the environmental context, and the postmodernism of Las Vegas by the antipathy between building and context, then the work of Takamatsu, through the work of Guattari, represents a third way between these two: by demonstrating a way that buildings can, like a face, create meaning and identity.

The history of the face
Part way through their plateau on the face, Deleuze and Guattari make a surprising claim:

'Primitives' may have the most human of heads, the most beautiful and most spiritual, but they have no face and need none ... The reason is simple. The face is not universal. (Deleuze and Guattari, 2004: 195–96)

What do they mean when they say that primitives have no face and that faciality is not universal? Surely it is absurd to suggest,

as they do, that faciality only gained prominence with the coming of Christ and then only in relation to the white European male? How can the face be thought of as a cultural phenomenon and how can its importance be linked to a specific time period? Statements like these seem somewhat ludicrous, or at least provocative. However, we must not forget that Guattari deals not with the face as a biological entity; instead he regards its importance as a shaper of identity and as a reflector of semiotic meaning.

Deleuze and Guattari make the notable point that, for non-European cultures especially those emanating from Africa and Asia, the face has less cultural importance. John Brophy, in his book on the face and art makes a similar observation on the prevalence and nature of its representation in Africa and Asia. He says:

To judge from what is called 'peasant art', the less sophisticated men are, the more they value decoration at the expense of life-likeness. Thus the portraiture of Ancient Egyptian temples, Greek vases, American Indian and African Negro carvings, is hardly recognizable to us as portraiture at all: the likeness is subordinated to the decorative convention. (Brophy, 1945: 117)

If we ignore Brophy's vaguely old fashioned terminology here, and his seemingly unshakable faith in the cultural superiority of Europe's Quattrocento, we can detect a similar sense of the rise in the importance of the face: in non-European art (Deleuze and Guattari use the term primitive but have the good grace to employ the use of speech marks) the face becomes less important, less tied to the cultural tradition and, moreover, less central to the notion of the aesthetic experience. In fact, Brophy goes further and suggests that portraiture, as we know, does not fully develop until the fourteenth century with the rise of the merchant classes who, we could guess were rich enough and egotistical enough to want to see themselves immortalised in paint.

Deleuze and Guattari claim that it is the body that forms the basis of many non-European, pre-Christian aesthetic practices. Whether it is the Greek statue or the African dance, the corporeal

rather than the facial dominates, suggesting a more kinetic, polyvocal and polymorphous relationship to the text and the aesthetic experience. Robert Brain's text, *The Decorated Body*, for example, details how bodily practices such as scarification and modification dominate non-European and pre-Christian subjectivity but have remained marginal to the vast majority of European cultures. Some of the exoticism associated with the sailor's tattoo after all was surely a form of borrowing from the faraway places they had been to, and the cultures that they had met there. This rendered them equally excluded in the eyes of the normalised social economy.

Of course, this polymorphous aesthetic sense is partly a reflection of the wider cultural milieu. In a culture that stresses the communal and the democratic, the individuation of the face is likely to be considered less figuratively important than in a monotheistic society. In a religious system that is based on the transubstantiation of spirit to animal (for example) the notion of the fixed human form, and the face that provides its ground, is likely to be less important than one in which the deity has a fixed and recognisable form. Only in a society that values the processes of subjectivisation and identity can the face take centre stage, and only in a culture that privileges the one over the many can it assume the primary social role. For Deleuze and Guattari, the beginning of this culture was the birth of Christ, Year Zero.

The image of Christ provided Christian culture with an archetypal face, one that combined the two movements of signification and subjectivisation. In one foundational image, the white wall and the black hole coexists in almost equal measure. The face of Christ, they assert was the beginning of faciality:

The face is not universal. It is not even that of the white man; it is the White Man himself, with his broad white cheeks and the black hole of his eyes. The face is Christ. The face is the typical European, what Ezra Pound called the average sensual man ... (Deleuze and Guattari, 2004: 196)

We begin to see recognisable paintings of Christ's face around the fourth century when they appear in both paintings and murals, but already we can begin to note the presence of the familiar features that will become the prototypical face of the European against which all other races and cultures would be compared. Many, if not all of these early images are depicted head-on, the eyes fully visible on the white surface of the skin. Occasionally, as in Fra Bartolomeo's *Christ with the Four Evangelists* of 1516, we see the eyes of the Christ figure angled downwards in peaceful contemplation or more often, as in Grünewald's Isenheim altar piece, at the moment of death. But, by and large, the features of Christ are pictured with both eyes equally visible, staring out of the painting and connecting directly with the viewer.

Images of Christ are remarkably constant. Occasionally he is depicted with no beard (as in the Basilica di San Vitale at Ravenna that depicts a clean-shaved Christ with a reasonably neat haircut, looking not unlike a young Paul McCartney!), but generally we see the same facial traits and the same ethnic make-up in all of the early images. For Guattari, the face of Christ became the face against which all others were compared. The white skin, the dark eyes, the high cheekbones, the thin lips, the beard and the long straight dark brown hair have all been used as an archetype with which to measure the faces of other people and, most particularly, other races.

Here, as Robert Porter states, is where Deleuze and Guattari differ from many of the other social and political theorists of the late twentieth century who stress the importance of alterity in relation to racial others. Edward Said's concept of Orientalism, for example, an aesthetico-political perspective that posits the construction of psycho-social others by eighteenth- and nineteenth- century Europeans stressed the importance of the cultural binary of inside/outside in the formation of art and literature of the period. The image of the rational, reasoned and

enlightened European mind, according to Said, was seen as the primary ontological presence. Thus the concept of the primitive and the civilised man is the formal manifestation of a cultural assumption that divided the globe into 'us' and 'them'. Franz Fanon also recognises this dynamic when he talks of the inferiority of the black man in the twentieth century coming into being 'through the other', a clear binary with the divisive and dividing notions of exterior and interior.

Whether it is the kind of blanket 'othering' that Said and Fanon speak of, or the more liberal acceptance of the racial difference in Charles Taylor's notion of multiculturalism, the binary of insider and outsider seems to perpetuate contemporary notions of racism and race relations. It is both a foundational precept that is challenged and also something upon which to base racism on in the first place. How many xenophobic newspaper images and headlines rely and uphold this binary of included and excluded, inside and outside?

Deleuze and Guattari, however, deny the racist such a comforting and foundational alterity. For them, white supremacy is based not on otherness but 'waves of sameness', not on the simple binary but on a spectrum of difference that recognises not exteriority, only faces who differ from the white one. It is this, they say, that makes the face a politics. It is this that is used as a benchmark to judge other people, a sliding scale of racial correctness, the constant checking and re-checking of whether your face fits, whether your features conform. The face then is also a machine of selection; it sorts and categorises, fits you into your social position and cultural heritage based on the blueprint image, Christ.

This is what makes faciality an abstract machine as it provides the plan for the concrete machine of social selection. When we view racist images it is the facial features that are most often exaggerated, the degree to which each race either conforms or does not conform to the archetypal white European Christ.

Dismantling the face - we're all in a bag baby!

So, the face is a politics, as a source of power and discrimination. It is easy to see how this works because without the face there is no delineation, no prejudice and no prior assumption. Without a face it is difficult to hate.

In 1968 John Lennon announced to an astounded press conference in Vienna that he was going to conduct the interviews from a large cloth bag, and thus the notion of 'Bagism' was born. Bagism was a loose concept that neatly exemplifies what we could think of as 'face-dismantling'. For John Lennon, the bag allowed pure communication; participants in the press conference were encouraged to listen and interact without assumption or prejudice. They asked questions to him and Yoko Ono and they answered and played music from their bags. Many were unsure as to whether they were even in there at all! As Lennon explained sometime later to David Frost, 'If people did interviews for jobs in a bag they wouldn't get turned away because they were black or green or [had] long hair.' This is perhaps a typically idealistic view but it is one that comes close to how Deleuze and Guattari conceived that resistance could be carried out.

In place of Bagism, Guattari suggested dismantling the face, thus allowing it to deterritorialise, to destroy itself and the abstract machine that drives it. There are two ways you can unravel the machine of faciality and thus destroy its inherent racial and cultural divisions. First, you can improvise. You can make a black Christ for example, like the statue of El Christo Negro in the small church of Portobello in Panama. Or, like the homoerotic images of Robert Recker, you can create a gay-Christ, a woman-Christ or an animal-Christ. The face here remains the same but the meanings are different; you have performed a subtle alteration of intent.

The second way is to explode the face, to make it indiscernible like the paintings of Francis Bacon, that depict human figures with faces that have literally and figuratively been blown apart.

No longer do we easily read the expressions on Bacon's faces. The simple binary of white wall and black hole through which we understood *City Lights* is no longer applicable, as we are presented with flesh that has become imperceptible, malleable and molecular. Bacon's portraits were studied in Deleuze's book *The Logic of Sensation* but they are equally pertinent to Guattari's work, in that they represent the desire to go beyond the mere representational into a more affective, transversal realm. Bacon's depiction of the face in turmoil – the scream, for example, in the portraits of Pope Innocent X, is a clear example of becoming-animal, the exchanging of genetic code between animal and human that results in a median state. In the Pope Innocent X paintings, the face exists as a point of terror, throwing off signification, hitting us in the stomach. The power of the image is in the deconstruction of the face that inevitably also equals a disintegration of the self. The simple equation of visual semiotics (this means this and that means that) are elided in favour of affect and sensation. This is the power of the Francis Bacon portrait: the terror and the glory of a face and an identity being torn apart.

When we dismantle the face, we dismantle the binaries of subjectivity and identity, allowing lines of flight to tumble out of the black hole and crawl over the white wall. As Deleuze and Guattari warn us though, dismantling the face is dangerous. Schizophrenics often lose their faces and do not recognise themselves in the mirror. They sometimes give up the face altogether. Like many other concepts in Guattari, faciality skirts the borderline between sanity and madness and suggests that, in order to transcend the usual binaries that entrap and enslave us we also have to run the risk of losing our selves entirely.

Chapter 7

The refrain

The refrain is a concept that marks the mid-way point between Deleuze and Guattari. Whereas other concepts can be traced back to one or another, the fundamental characteristics of this idea largely pertain to both of their philosophical mandates. Deleuze's ideas of the virtual and the actual, and difference and repetition, and Guattari's notions of 'chaosmosis' and the existentialising function of actions can both be found in the refrain; or as it is sometimes translated, the *ritornello*.

Deleuze and Guattari dedicate Plateau 11 to the refrain and begin with an uncharacteristically sentimental image: a young child humming to itself in the dark:

A child in the dark, gripped with fear, comforts himself by singing under his breath. He walks and halts to his song. Lost, he takes shelter, or orients himself with his little song as best he can. The song is like a rough sketch of a calming and stabilizing, calm and stable, center in the heart of chaos. (Deleuze and Guattari, 2004: 343)

We can all identify with this picture. When you have been walking home at night, how many times have you begun to whistle, to hum, to stave off the fear and anxiety that you feel with a short snatch of a song that reminds you of safety and comfort? How many times, when you are at your most nervous have you found your feet tapping on the floor or your finger drumming on the table in front of you? We are consoled by repeated movement, palliated by a sound that we know and feel comforted by. Rhythm

makes us feel at home, it draws a circle of protection around us and makes us feel warmer. As Deleuze and Guattari assert, rhythm is nothing more than repetition, the simple return of that which has gone before – the refrain.

The refrain is the portable home that we carry about with us, and is in fact used by us all the time. For example, travellers are often advised to take a favoured candle with them when staying in hotel rooms, as the familiar smell creates a kind of home away from home even in the barest of motels. Children often ask bemused and bored parents to constantly read the same passage of a book over and over again, or to sing the same song until it becomes a meaningless barrage of words. As the parent gets increasingly bored, the child laughs and wants to hear it again. We could assume here that the familiar takes on an extra existentialising function, one that goes beyond the usual semiotic meaning of language or musicality, one that has some deeper meaning that roots us to who we are and where we have come from. The refrain of a song signals that order has returned; that familiarity has been reached. It is a calm place in the chaos that surrounds it.

However, for Guattari, this is only the refrain's first function. There are two others. The second is far more spatial and pertains to what we might think of as the environment of the domicile. It is the circle or the yard that we draw around us: the refrain delineates and describes a territory; it keeps others at bay whilst at the same time outlines a perimeter, a safe zone. Think of the bird singing or the dog barking. This noise does not merely ward off others, it acts as a kind of virtual fence around whoever is emitting the sound. It enters into a relation with the centre, the home, describing both an outside and an inside with sonic barriers. The refrain is that which divides the home from the not-home. Sound can be used to block out others and to draw lines of demarcation. The singing of the crowd at a football match is as much a spatial act as a psychological one. The voices on the

terraces form a virtual territory that links the group to the individual and traces the various encampments; the fifes and the drums of medieval warfare did the same. When it sings in unison, the crowd is doing more than showing its support for its team, it is describing a physical presence and fencing off an area: the louder the song, the wider the territory. The refrain here, the short snatches of song ('Come on you reds!', 'You only sing when you're winning') are a consoling and palliating expression of territory that acts like birdsong, keeping others at bay but also staking a spatial claim. This is our patch of ground, this is our song.

The last aspect of the refrain, for Guattari, is its line of flight. In order for a home to be recognised as such it must constantly be held in comparison with a route out. A return (even in a musical sense) can only exist if there is an equal force away from it. The jazz musician knows this well. The refrain or the head, for example, only gains meaning when it is held in relation to the improvised sections that flank it, as the excitement and chaos of the riff eventually has to be anchored by the repeated familiarity of the chorus. Whereas it might be Miles Davis' improvisation that lets our spirits and hearts soar, it is Rodgers' and Harts' refrain that creates and shapes 'My Funny Valentine', turning it into a song. The refrain anchors the composition for both musician and listener. It is what makes the tune possible but also what will inevitably destroy it. One cannot exist without the other.

So, the refrain consists of three elements, or three interconnected concepts: the centre, the periphery and the way out. It becomes, in other words, a method of ordering space-time and is intimately linked to the concepts of territory and milieu. The refrain is that which divides up the chaotic pre-territorial plane, what Deleuze and Guattari call 'the milieu of milieus', and provides points of demarcation, of difference between one territory and the next. It is thus a vital existential tool. The refrain sets up a rhythm that allows assemblages to co-exist and to communicate with each other, providing both a centre and a line of flight. Think of the body,

what is it but an environment, a milieu that resonates with its own rhythms? There is the constant beating of the heart, the coursing of the blood through the veins, the rhythmic digesting of food, the firing of synapses and so on, all producing different refrains and different rhythms. And yet, all of the organs communicate with each other, each one has their own rhythm and their own function. The body is a series of different rhythms, repeated refrains all chiming together in the milieu of flesh and blood. It is their differing rhythms that separate the blood from the flesh, the bone from the hair, the brain from the flesh. For Deleuze and Guattari this also describes the working of the cosmos which is itself merely a series of resonances, from the pulsing of a star to the vibration of quartz crystal. Different refrains reflect different substances and bodies. Those of you familiar with Spinoza will recognise this idea in his major work, *Ethics*.

Deleuze and Guattari employ ethology (the biology of behaviour) to highlight the extent that the refrain constantly occurs in nature, most specifically in the territorial behaviour of birds and animals. They cite, for example, the brown stagemaker bird that places upturned leaves around the edges of its territory, not to act as a warning to others, but as a way of shoring up its boundaries, of creating a home for itself and its mate. The leaves are placed on the ground in a regular pattern that is similar to the fencing off of land by humans. This is the avian equivalent of painting the picket fence white, or staking out one's patch on the beach with towels and windbreaks. For Deleuze and Guattari these leaves are more than mere placards denoting display or danger, they are rhythm turned expressive. They are spatial and extended manifestations of affect and desire, acting as a reflection of a pre-personal proto-subjective instinct. The stagemaker utilises the refrain in a physical sense to create a home, a yard and ultimately a line of flight that can be retraced.

In his essay 'Ritornellos and Existential Affects', Guattari states categorically that the refrain need not be thought of

merely in terms of music or sound, it can be anything that fulfils the three functions we have outlined here – a smell, an image, a word, a feeling, a place and so on. As long as there is a home, a yard and a line of flight we can think of it as a refrain. So, let us see how it can enable us to understand our relationship to three essentially different fields: literature, art and cinema.

The Proustian refrain

Guattari posits that Proust's *In Search of Lost Time* encapsulates the subjectivising nature of the refrain. It is a novel that depends to a large extent on the return of the familiar: a face, a smell, the brief sound of a voice, and of course most famously, a taste, all attesting to the threefold articulation of the refrain. This is a point we see most clearly in the trope of the madeleine. More words have been written about this small item of patisserie than perhaps any other cake in history. The image of the infirm and weakened Proust, lying in bed dipping the orange pastry into a small cup of tea has fascinated writers and thinkers ever since it was written, so it is worth reminding ourselves (in a refrain-like manner) of how it goes:

…as I came home, my mother, seeing that I was cold, offered me some tea (and) she sent out for one of those short, plump cakes called 'petites madeleines … and soon, mechanically, weary after a dull day with the prospect of a depressing morrow, I raised to my lips a spoonful of tea in which I had soaked a morsel of the cake. No sooner had the warm liquid, and the crumbs with it, touched my palate than a shudder ran through my whole body, and I stopped, intent upon the extraordinary changes that were taking place. (Proust, 1989: 101)

The taste of the cake sets Proust off on his search for lost time, it acts as a prompt, as an anchor-point for a personal journey through memory and the past. The madeleine is not an inert fragment of memory dredged out of the past but an instigation of some future repetition. It is a marking of temporal territory that is yet to come. Similar to an anniversary, it does not commemorate so

much as set precedence by ascribing some future terrain that will be inhabited. It is interesting to note that, in this extract, Proust stresses the affective role of the madeleine – the shudder that he feels upon tasting it, that it seems to resonate with all of his senses at once. It is precisely the pre-cognitive, pre-personal feeling that will come to dominate both Guattari and Deleuze's aesthetic after *A Thousand Plateaus* and that we have already associated with the instincts of the stagemaker bird. For Guattari, the refrain is exactly this – the coming together of the inner world of the affect with the outer world of action and territory. One imprints on the other in a mutual, rhizomatic way. It is not as simple as saying that the refrain enacts some inner desire or results in some outer effect (the demarcation of territory, for example). The two elements are one and the same thing, an assemblage.

We can see the three-fold elements of the refrain in this section from Proust: first, there is no doubt that the taste of the madeleine sets up a home or a centre for the narrator of *In Search of Lost Time*. In many ways this is what is at the heart of the novel, as the search for lost time is also a reflection of a search for a lost home. Secondly we have the spatial and temporal setting of boundaries. Combray and the narrator's past form as much a territory as any birdsong. Lastly, we have the line of flight: the taste of the madeleine is evanescent; it elides the narrator, constantly leaving him and prompting him to go on new, uncharted journeys, as attested to in the next few lines of the passage:

I drink a second mouthful, in which I find nothing more than the first, a third, which gives me rather less than the second. It is time to stop; the potion is losing its magic. (Proust: 102)

As Guattari points out, Proust's novel is a universe of refrains each chiming and resonating with each other. The little phrases of Vinteuil, the uneven paving stones in front of the Guermantes' Hotel, Odette's face and so on all create what Guattari called 'ritornellos of times past', refrains that organise and structure

the chaos of memory and existence. Proust traces these returns throughout his novel, allowing them to flee and then return again, to form new connections and create new refrains.

The Duchampian refrain

Proust's writing describes the process of the refrain as it is experienced by both the author and his characters. It adds consistency to the novel and structures the narrative, which itself becomes a form of refrain as images and tropes are revisited time and time again – an act which forms what can only be thought of as a Proustian rhythm. Aside from Proust, however, Guattari also cites the work of Marcel Duchamp as being particularly pertinent to the refrain, especially his 1914 work 'Bottle Rack'. 'Bottle Rack' was one of the first of Duchamp's 'readymades', mass produced everyday items that could be transformed into an artistic object through re-positioning or re-contextualising. Culminating in the infamous 'Fountain' of 1917 (the upturned porcelain urinal) the readymade not only displays aspects of transversality, the object spanning numerous aesthetic and ontological modes, but also acts, as Guattari himself states, 'as the trigger for a constellation of referential universes engaging both intimate reminiscences … and connotations of a cultural or economic order' (Guattari, 1996: 164). 'Bottle Rack' prompts a particular affect born of a specific cultural milieu. It is both familiar and strange, providing the viewer with both a sense of home and a line of flight. We are unused to seeing such an everyday object in the context of the art gallery but it inevitably acts like Proust's madeleine and causes us to return to some memory or some feeling that we have experienced before.

Guattari suggests that this form of refrain can be thought of in the same vein as Walter Benjamin's notion of the aura or, more correctly we could assert, Roland Barthes' punctum. Both of these ideas present what Guattari calls a 'singularizing rittornello', in other words, each individual viewing such an object will have a noticeably different relationship to it (a different refrain, a

different temporal rhythm) which singularises and individuates its viewers. Each viewer will connect to 'Bottle Rack' in a different way; they may remember the dampness of the cellar; they might recall the smell of the drying bottles of the sound they made when they were attached. Each sensory experience is both personal and cultural, both stadium and punctum.

'Bottle Rack' then, acts as a form of visual refrain, centring the viewer with a geographical and temporal home by delineating a periphery and offering a line of flight. The affect (and effect) is of singularisation, creating subjectivity out of memory and personal experience.

The Hitchcockian refrain

Hitchcock was to remake only one of his films during his lifetime, the 1934 British-made *The Man Who Knew Too Much*. The 1956 remake, starring Doris Day and James Stewart has often been seen by critics as being somewhat superior to the original both in terms of cinematics and in terms of character development and performance. Hitchcock himself famously described the first film as being the product of an enthusiastic amateur and the second as being the work of a seasoned professional.

Whatever your opinion on the relative merits of both movies, one thing is certain: they are noticeably different. The 1956 version is half as long again as the 1934; it is in searing Technicolor; it is set in Morocco rather than the less exotic Switzerland; the family are American rather than British; the couple's child is a boy rather than a girl; it ends in harmony rather than a siege and so on. However, perhaps the major difference between the two is the importance of music in the narrative. The 1956 version of *The Man Who Knew Too Much* is the only Hitchcock film where music plays a vital role in the narrative. Even in the 1957 film, *The Wrong Man*, in which Henry Fonda plays the wrongly convicted jazz musician, Manny Balestrero, music is merely an afterthought. In *The Man Who Knew Too Much* it is an integral part of the plot.

Critics such as Robin Wood have also observed that both versions of the film deal, in the main, with issues of gender and of motherhood. In the original, Jill Lawrence (Edna Best) presents a markedly different figure to the more overtly nurturing and feminine Jo Conway (Doris Day). Even though both are mothers, the 1934 film depicts motherhood as an adjunct to a fulfilled and exciting life, whereas the 1956 version traces the entrapment of women within the nuclear family. Jo Conway has been forced by her husband to give up her singing career and become instead a passive wife and mother in rural Indiana. As Robin Wood details, the fact that Jo takes too many pills and desires another child is testament to her discomfort adopting this particular role.

There are many connections between the remake of *The Man Who Knew Too Much* and the opening passages from Plateau 11 of *A Thousand Plateaus*. Just as the child hums to itself to ward off fear and to create a sense of home as a calm and stabilising centre, so the refrain is used in this film to not only allow the characters to experience the familiar, but to allow the audience to do so as well. In the 1956 version, Doris Day presented the image of the ideal mother and wife. On the surface she was a strange choice to play a Hitchcock blonde, known as they were for their cool and detached sexuality. But, like in many areas, Hitch knew what he was doing: Day is the ideal mixture of sexuality and the maternal. She is at once a wife and a mother, offering a brand of comforting familiarity for the audience – a form of visual refrain.

However, Day was also a singer, known especially for a particular brand of smaltzy popular song of which 'Que Sera Sera' is a most notable exception. The refrain in this song is both maddenly memorable (try not to watch the film without it embedding itself in your head) and vital to the plot: both times it is played it is a reminder of home. This first occurs when the family are in their Moroccan hotel room after spending an alienating and disturbing day travelling. It also features in the final scenes of the

film when the family are once again reunited after the kidnapping. In the second instant particularly, we witness the threefold movement of the refrain. First the chorus of the song is used as a means of reaching Hank, literally giving him comfort and stability as he sits with his thumb in his mouth on the chair of the kidnappers. Secondly, the song expands to fill the room of the embassy, creating a form of home away from home for the family, encircling them and bringing them together. And lastly, as the camera moves up the stairs following the lilt of the tune, we realise we are being taken on a line of flight that will eventually return.

Much of the criticism of the 1956 remake has surrounded the extended exposition shot in the Marrakesh market. These scenes which last nearly 45 minutes do not appear at all in the original and contribute greatly to the difference in time between the two films. However, viewed in terms of the refrain it is easy to see how crucial these are to the flow of the narrative, manifesting as the chaos out of which order must be fashioned. These scenes, with their exotic unfamiliarity and their cultural alienation are the non-home in which home must be found. This is done through a variety of means, not least of course through the use of the musical refrain.

Robin Wood's analysis of *The Man Who Knew Too Much* stresses the importance of gender to the film. For Wood, the 1956 remake highlights the internal domestic battles that were raging in the 1950s American nuclear family: Jo has been forced by Ben to give up her singing career and become a wife and mother. She seems to accept this passively, but in the earlier sections of the film in particular, the couple bicker in such a way as to suggest that not all is well inside their stereotypical domestic set-up. The end of the film signals a return to gender normality as the mother–father–child Oedipal triad is restored through the power of the refrain. Order is established and chaos, for the moment anyway, is kept at bay.

Of course, in terms of Guattarian philosophy, the notions of chaos and order do not have the same connotations as they

might have elsewhere. For Guattari, chaos was a liberating force, an expansion of milieu and a multiplication of possibilities. The movement from chaos to order and back again was the inherent flow of the rhizome that puts out feelers into other arenas, creating new forms out of old ones. The refrain can be thought of as a mechanism to allow this to happen. It is at once a centre and a means of escape.

This second section has presented a series of conceptual tools that were mainly developed by Guattari and Deleuze in their two books *Anti-Oedipus* and *A Thousand Plateaus*. It is impossible to underestimate the importance of these two works on the career of Felix Guattari, but it is a mistake to think that his work ends here. In this next section we will move on to examine his post-Deleuze work, how he took many of these same ideas (schizoanalysis, the refrain, the machine) and created a philosophy that was deliberately political and socially engaged. In his later work Guattari became more idealistic and enamoured with the idea of micropolitical revolution. For him this was not merely a possibility but an imperative. In order to survive as both a species and a planet, he would assert, human beings had to adopt different ways of approaching all areas of intellectual life, from art and literature to the environment. From the age of the *Anti-Oedipus* we now move into the new aesthetic paradigm...

Part Three: How to think chaosophically

Chapter 8

Molecular revolution

The personal and the political

In his large biography of Deleuze and Guattari, *Intersecting Lives*, François Dosse pays scant attention to the period between the publication of *A Thousand Plateaus* and *Chaosmosis*. This period, roughly spanning the 1980s came to be known as 'the winter years' by Guattari himself who displayed an ever-deepening sense of disillusionment and disappointment at the political and cultural scene of both France, and the rest of the world. These were the years of Reaganomics, Thatcherism, McDonaldisation, postmodernism and globalisation. Despite the brief light of the left-wing Mitterand government in France (a light that was to dim in Guattari's eyes some years later), it was a divisive and destructive time for the leftist cause. Much to Guattari's disgust, neo-conservatism grew stronger, whilst effective opposition in the form of worker's unions or collectives foundered and became weak through in-fighting or lack of political will. What Francis Fukuyama was to later call 'the end of history' was, in effect, merely the end of the dialectic between right and left – nationalism and globalism.

This position was made worse by the rise of postmodern theorists such as Jean François Lyotard and Jean Baudrillard. Guattari thought these two figures embodied a form of academic quiescence that mirrored the general malaise of a globalised world that had given in to mediated capitalism and was revelling in the blandness of homogenised globalisation. In a

series of papers, Guattari highlighted the need to develop new tools of political and ontological understanding which would allow resistance to universalise socio-politics whilst still retaining the specific character of a subject group. These molecular revolutions would take many forms, but would all attempt to do the same thing: to throw off the constrictive structures of late twentieth-century capitalism and its micropolitical manifestation in the psyche.

Molecular revolution is opposed to the molar revolution of political overthrow. It chips away at the status quo, brings disparate groups together (like the anti-capitalist movement) only to have them fall apart again before they can solidify into acquiescence. Molecular revolution works on the micropolitical plane and is something that we can all participate in through our involvement in local interest groups, alternative sexualities, familial relations and so on. Molecular revolution, in other words, is in our own hands!

The winter years were also characterised by a marked decline in Guattari's own mental health, as he slumped deeper and deeper into a depression that would never fully leave him. Through financial trouble, he was forced to give up the two homes that he loved (one at Dhuizon and an apartment in the Latin Quarter of Paris) and move into a small house near La Borde that he was to share with his problematic second wife, Josephine. Josephine was a drug addict and adulterer who Dosse describes as 'a love affair that began well but proved deadly' (Dosse, 2010: 425). It is not known how far Josephine contributed to Guattari's ill health in these years, but he was constantly heard complaining about the financial troubles that her addiction was causing him.

These events had both a symbolic and a practical impact upon Guattari and his working life. They were to shape his writing until his death in 1992, imbuing it with a curious but distinctive mixture of hope and melancholic paranoia. The

philosophy of the 1960s and 70s gave way to a frenetic activism in the 80s that would never really coalesce into a distinct and homogenised vision. Guattari's political ideas were grander and more wide-ranging than his work with Deleuze, encompassing areas such as the environment and gay rights. His work also lost some of the precision of *A Thousand Plateaus* and *Anti-Oedipus* – a situation that was, undoubtedly, due to his hiatus from his friendship with Deleuze who had always acted as the polisher to Guattari's rough hewn notions.

During this period Guattari also lost his mother, an event that proved crucial in the continuance of his illness, as Dosse details:

This was a particularly inauspicious moment for him to be wrenched from his familiar spaces and their ritornellos, as his dislocations coincided with his mother's death. The haranguer of familial life repeated over and over again how painful his loss was. He kept saying he was an orphan. (Dosse, 2010: 423)

By the mid-1980s Gilles Deleuze was working on his monumental work on cinema, and several monographs on philosophers such as Foucault and Leibniz. He was also fast becoming a respected and established academic on the Paris scene. Guattari, however, was left to slide into an ever-deepening morass of almost catatonic bleakness. Although he was well known for his work with Deleuze, friends report that during this time, Felix could be found staring at the television, not saying a word, caught in a world of his own like the schizophrenics that he had so passionately treated and defended at his clinic 20 years before. His co-workers at La Borde attempted to aid him in his recovery but little they did or said seemed to help.

Despite the pervasiveness of his depression, however, Guattari continued to write and be engaged by global politics. The essays and papers of this period display what could be thought of as his innate spirit of humanity as he struggled to find a form of optimism in his deteriorating mental state. Despite dealing with

large global political systems, the work of this period resonates with a determination to remain hopeful about the future. It was almost as if his troubled private life was being projected onto the screen of the class struggle. These were times of distinct and unerring depression but they were underlined by a constant hope that things could, and should, get better. It seemed as if his private struggles were being played out on a global political canvas.

One of the major tropes of this period was the development and concretisation of the 'molecular revolution', a concept that was born out of the 1968 protests and that provided the foundation for the more political aspects of his work with Deleuze. Guattari became increasingly convinced of the futility of traditional avenues of political resistance such as the Marxist-inflected class struggle. Far from engendering a long lasting social and political change, it merely resulted he concluded, in further oppression as the subject group of proletariat revolt ossified and calcified into the totalitarian subjected groups of Stalinism and Maoism. By the 1980s, Guattari had concluded that the capitalist system was so pervasive, so powerful, that it had literally engrained itself into the psychologies of those that it served and that served it. In fact, this was so much the case that it was virtually impossible to overthrow it completely without also abandoning the semiotic structure of society itself. The real question then becomes: How do you ensure effective revolution without falling back on the regimes and structures that such revolution overturns, and, how do you provide effective resistance against a system that is so all encompassing? Guattari was to die before the development of large cultural franchises such as *X Factor* and *Big Brother* but they certainly exemplify the subjectivity-producing media enterprises that he warned us against.

Soft subversions

Increasingly, Guattari saw the answer to these questions as resting with the personal acts of revolution that we can all perform each day of our lives. Rather than a full-blown social revolt on the

scale of Russia or Cuba, instead what was needed was a million minor revolutions. These small acts would challenge the capitalist status quo from the inside, subverting it and exposing its own internal fissures. Soft subversions seek to utilise the tools of the state against itself. They represent a becoming-rebellious; they have no distinct political mandate but instead coalesce around local or personal issues and seek to attack the monolithic edifices of the patriarchal capitalist system. Soft subversions deterritorialise the striated structures of accepted society: the crèche in the heart of the corporate office block, for example, provides a point of fluidity and chaos in an otherwise rigid and compartmentalised world. Think also of the internet forum that provides a point of virtual resistance to the powerful voice of the mass media. It consists of multiple perspectives and endless variations of micropolitical desire. These are acts and tools of resistance that can be utilised by anyone at any time to potentially lend a powerful counter-discourse to the hegemony of globalised capitalism.

The conceptual artist Michael Rakowitz constantly attempts to provide such resistive points in his work, transversally spanning the disciplines of art, social commentary and economic welfare. Rakowitz's art is politically engaged, but centres itself on the personal experiences of those marginalised by mainstream society – the immigrant, the homeless and the dispossessed, attempting to micropolitically subvert the molar narratives of Western capitalism from the point of an immanent critique. His work mirrors Guattari's attempt at encouraging revolution on an everyday, micropolitical level. It is also centred on the desires and wishes of individuals, especially those outside of the mainstream norm.

In his 2001 work *RISE*, Rakowitz used the highly molecular sense of smell to provide a counter-discourse to the heavy handed practices of New York real estate agents. Despite the protests of local demonstrators, the estate agents persisted in their policy of buying up buildings in the poorest parts of the city. This meant

evicting the existing occupants to make way for redevelopment and modernisation. In order to lend the development artistic cache, the agents pursued a policy of commissioning well-known artists to hold exhibitions in the spaces before development work took place. One such building was 129 Lafayette Street in Manhattan's Chinatown. A temporary exhibition was held in this previously inhabited building by the real estate company Tri Beach Holdings and Rakowitz was asked to contribute. The resulting work consisted of a 36-feet-long air duct that transported the smells of the local Chinese bakery into the empty apartment block. In effect, visitors were presented with the molecular ghosts of the building's past; its evicted immigrant population literally mixing with the air of the newly refurbished corporate structure. Visitors to the exhibition were drawn to the bakery itself, made purchases, interacted with the owners and engaged in conversation with locals about the nature of Tri Beach's development strategy. It was, in other words, an exercise in opening up the transversal borders between spectator, artist and surrounding community.

RISE not only utilised the molecular's ability to transcend regulated space but also asserted the primacy of the immigrant population's identity. Further, it also provided a point of resistance to the blandness of the economically driven condo-isation of the New York demographic skyline. Smell was used as a way to undercut the oppressive rigidity of big business. The aroma from the bakery could go anywhere, entering the very brickwork of the building and the bodies of those who visited it. The experience of spectatorship was one of becoming, of joining with the exhibition both corporeally and intellectually. However, it was also a singular event. It related to the particular group struggles of disaffected and disenfranchised immigrants, and once the exhibition was over Rakowitz turned his energies elsewhere. Like the molecular nature of a gas, *RISE* was short lived but intensive.

In another work, titled 'paraSITE', Rakowitz once again bridged the gap between art and social welfare. The paraSITE

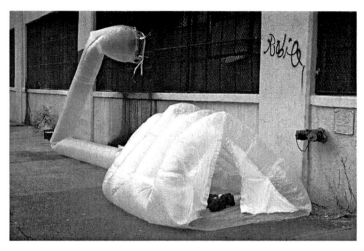

4. Michael Rakowitz, *paraSITE*
(2001), mixed media.

project consisted of a series of shelters made for the homeless that could be attached to the heating ducts of large corporate buildings, offering both warmth and a sense of the refrain to those on the street. The shelters were constructed out of materials that were readily available such as plastic bags and duct tape and were specially designed with the personality of the end user in mind. This not only provided a reasonable form of cover for the homeless, but also imbued them with singularity and individuality. ParaSITE was, at once, an aesthetic and a socio-economic exercise. The shelters' end users are not only part of an extended artwork but are also consumers of a product. This again displays Rakowitz's preoccupation with utilising the very system that he critiques. In paraSITE we see a clear example of the Guattarian notion of micropolitical subversion. The heat from the outlet pipes (an otherwise waste product of capitalism) is reclaimed and re-semiotised by the artist and the end-user, in what is ultimately a

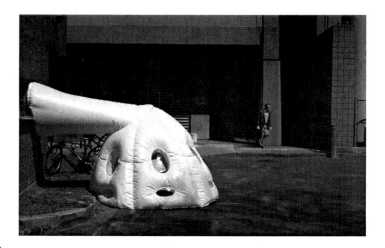

5. Michael Rakowitz, *paraSITE*
(1998), mixed media.

revolutionary act. One of the shelters was even designed to be less than 3.5 meters high in order to evade the recent injunction on tents and temporary structures on the streets of New York. However, paraSITE is by its very nature temporal. The shelters change and transform over time making sure that they never calcify into iconic status. The work's processual nature means that it evades the embourgeoisment inherent in art. The shelters are constantly changing homes rather than calcified objects in a gallery or museum. This lends to them a molecular temporality that defies easy categorisation.

Rakowitz's work represents a coming together of the personal and the political. It is an attempt to create a cultural singularity out of the ritornellos of the New York Chinese American experience, effectively using smell as a line of flight for both spectator and local community. It is recognisably political and noticeably individual, in a way that is undeniably Guattarian.

These soft subversions, or molecular revolutions, can be enacted by anyone at any time. Their aim is to disrupt the homogenising and univocal subjectivity of the capitalist economy, often through a bodily or overtly sensual process of rupture. In *Anti-Oedipus*, Deleuze and Guattari traced the construction of the self through mechanisms like the family and its psychoanalytic buttresses. In *A Thousand Plateaus*, they expanded this out to include the whole of the capitalist system. For Deleuze and Guattari, capitalism acts like a huge social machine, churning out specific ready-made lifestyles and points of view and reducing the complex heterogeneity of individual experience to a pre-packaged subjectivity. Subjective singularity became an increasing trope of his post-Deleuze work, as Guattari encouraged the construction of lifestyles and outlooks that would bring together the specific ritornellos of individuated existence.

Happy drag queens – becoming-homosexual

In many of his later essays Guattari displayed an interest in the micropolitical power of desire itself, especially as it is linked to alternative sexualities and marginalised behaviour. Ever since the 1960s, Deleuze and Guattari had supported gay rights (a decision that was to result in several speculations on the closeness of their own relationship), and in 1973 Guattari was arrested for producing an obscene publication called *Three Billion Perverts: The Grand Encyclopedia of Homosexualities*.

In essays such as 'I Have Even Met Happy Drag Queens' and 'Becoming-Woman', Guattari highlighted the ways that sexuality and alternative behaviour can offer a counter-voice to what he called Integrated World Capitalism, or IWC, by burrowing under its edifices of subjectivity production and threatening it from the inside. Concepts such as becoming-woman seek to challenge the sexual status quo by encouraging the effacement of gender normative boundaries and classifications. Acts of becoming-woman would not necessary result in transvestism or the kinds

of physical gender-swapping that litter certain Hollywood productions like *Tootsie* or *All of Me*, but would represent liberations of desire that transcend, and thus, question the simple binary of male and female. In this way an individual's behaviour can be seen as an inherently revolutionary act, as sexuality is used as a point of departure from the mainstream norm. This was a viewpoint that emerged in *Anti-Oedipus* and found resonance in the works of writers such as Foucault, Susan Sontag and the many queer theorists that came to prominence in the 1960s and 70s.

These are rhizomatic rebellions based in desire; minor acts of resistance that would transversally affect all manner of different areas from sexuality to art, from the micropolitical to the psychological. The insane, the drug addict, the criminal and the sexually different now took on extra importance in Guattari's world vision. They offered a way out of the bourgeois impasse of media-created subjectivity that produces made to measure lifestyles for global consumption. Guattari's interest in these groups was not as a detached voyeur but as someone constantly engaged with the construction of social and psychological selves.

In 1982 Guattari was invited by the Lacanian psychoanalyst Suely Rolnik to attend a series of conferences and events in Brazil. Brazil had just undergone a revolution and was experiencing its first democratic elections after nearly two decades of military dictatorship. What he found was not merely political and economic change but social and psychological as well. It was a situation that closely resembled his concepts of molecular revolution and soft subversion. Whilst in Brazil he not only met with political groups (for example, he interviewed the future president Luiz Inácio 'Lula' da Silva, then the head of the Brazilian Worker's Party) but also attended lesbian and gay assemblies. Guattari thought gay activists offered a specific form of resistance through their alternative behaviours and non-heteronormative lifestyles. In a meeting with a lesbian group in Sao Paulo, Guattari introduced the concept of becoming-homosexual, an idea that refers not to the

(homo)sexual act *per se* but to the effacement of the Oedipal behaviours that underline and provide a basis for the capitalist state. Homosexuality, for Guattari, effectively represents a sliding between the rigid poles of heteronormative desire. In this way it is inherently revolutionary and artistic, encouraging a blurring between subjective positions and allowing identity to become fluid and malleable.

The 2007 Uruguayan film *XXY* provides us with an ideal example of the artistic and cultural effects of becoming-homosexual. It tells the story of a young intersex teenager, Alex (Inés Efron), who struggles to find a sexual identity in a small coastal village where she lives. We learn that Alex and her parents have had to move house several times due to problems with the local population, a situation that persists as a group of young boys torment and abuse her on a beach one day. Alex befriends the 15-year-old son of a family acquaintance and sodomises him in a fit of teenage passion, an act that he is at first angered by but later admits that he enjoyed. Sexual identity in the film is pictured as being ever-changing, dependent on the physical and psychological make-up of the act's participants. Alex's body is a point of rupture in the striated space of the heterosexual economy. It is a smooth transition between man and woman rather than the abrupt alternative of the binary sexes. This gives her character a cinematic poetry that the other figures do not possess. The director, Lucía Puenzo ensures that it is her perspective that we are made aware of and ultimately her subjectivity we experience. However, this subjectivity is molecular in nature and her sexuality is portrayed as fluid and evanescent. Sometimes we experience the fear of the frightened teenage girl, sometimes the sexual energy of the aroused male and sometimes the confused frustration of the hermaphrodite. None of these experiences are the essence of Alex as her self is formed somewhere in the midst of these processes.

Through identification with Alex, the audience experiences some of the power of becoming-homosexual, as our viewing

position is never framed by a specific gender (in this way *XXY* also manages to offer an alternative to the monolithic statements of gendered film theory). She floats between sexualities and physical binaries, giving us what could be thought of as a perspective that is singularly Alex. Becoming-homosexual is not concerned with adopting alternative lifestyles oneself (although I think Guattari would not be opposed to it) but about freeing oneself from the constraints of normative behaviour, deterritorialising the inherent power of your desire and allowing your sexuality to overflow its traditional bounds. Enjoy yourself, live a little; it may well be a revolutionary act.

Towards the end of the 1980s, Guattari became interested in the American artist and photographer David Wojnarowicz. Wojnarowicz always skirted the extremes of society. He was a drug addict and a male prostitute who made his own extraordinary life the subject of his art, both celebrating and critiquing contemporary American ethics and culture. Wojnarowicz's work presents the viewer with a series of semiotic signs that undercut the usual bounds of interpretation, sexuality and Western history. High art and contemporary advertising are all blended transversally, to create a vision that is recognisably singular and that disturbs and arouses in equal measure. Wojnarowicz was reacting against a social machine that he saw as mediocre and stultifying. Works such as *Water* (1987) and *The Death of American Spirituality* (1987) resonate with a form of desperate idealism that chimed with Guattari's outlook in the late 1980s.

Wojnarowicz's stock of images included the cowboy, the buffalo and the steam train – all canonical symbols for the American West and its particular brand of mythopoesis. However, these would be juxtaposed and blended with homoerotic pornography and images of death and decay, to form an immanent critique that both eulogised and critiqued the American Dream.

We could suggest that it was Wojnarowicz's character that provided Guattari with the clearest example of molecular

revolution. He states that 'David Wojnarowicz's creative work stems from his whole life and it is from there that it has acquired such an amazing power' (Guattari, 1990: 1). Wojnarowicz exemplified the image of the artist maverick, rebelling against contemporary social and ethical mores and questioning the validity of homogenising morality. In a powerful mixed media image comprising of a photograph of him as a child surrounded by a disturbing and predictive text, Wojnarowicz describes the molecular revolutions inherent in alternative sexualities and lifestyles. The work, produced in 1990 states that:

One day this kid will get larger. One day this kid will know something that causes a sensation equivalent to the separation of the earth from its axis... One day politicians will enact legislation against this kid... This kid will lose his constitutional rights against the government's invasion of privacy... He will be subject to loss of home, civil rights, jobs, and all conceivable freedoms... All this will begin to happen in one or two years when he discovers he desires to place his naked body on the naked body of another boy.

For Guattari, as for Wojnarowicz, homosexuality represented a political act that liberated desire from the inherent constraints of heterosexuality and its Oedipal structures. In an interview with George Stambolian, for example, Guattari outlines his position:

I don't know if homosexuals can easily accept what I'm saying, because I don't mean to say homosexuals are women. That would be a misunderstanding. But I think in a certain way there is a kind of interaction between the situation of male homosexuals, of transvestites, and of women. There is a kind of common struggle in relation to the body. (Guattari, 1996: 206)

This common struggle was based on the Lacanian notion that the male is the possessor of the phallus whilst the female is its object: by possessing a desired body, the male homosexual subverts the traditional gendered power relationship of heterosexual normality, and thus forms an alliance with the female. It is not that gay men

become women but that they occupy a space usually allocated to them in society and thus subvert the traditional position in the desiring economy. Wojnarowicz's work reflects the subverted economy of homosexual desire, turning the male body into an object of sexual lust, undercutting the usual scopic tendencies of the male gaze. His work, for Guattari, was a form of cartography in which his own desire was allowed to overspill and blend with the myths and history of mainstream America. Wojnarowicz becomes a desiring machine that plugs into the machines of America – the advertising machine, the history producing machine, the myth machine. His art is the tracing of that process.

The winter years were a period of transition for Guattari. In his later life, as we shall see, he dedicated himself to combining his various interests in political activism, art and ecology. The period between 1980 and 1989 were formative in both his work and psyche, but they were also characterised by problems and anxieties that would, perhaps, never leave him.

Chapter 9

Cinematic desiring machines

Although Guattari was not as prolific a writer on cinema as Deleuze, it was a constant presence in his life that cropped up often in his writing. There is no sustained study of cinema in Guattari's work, but there are several highly evocative essays that seem to sum up his philosophy as a whole. It is therefore fitting that we should turn to them in the part of this book that deals with activism and practical philosophy. For Guattari, cinema was a machine for capturing desire; a giant processual technology that both reflected and shaped the desires of its audiences. Such machines pre-date the invention of film itself and can be seen in such cultural artefacts as tenth-century stained-glass windows, baroque art and architecture. It can even be seen in the ornate and stylised practices of courtly love in the fourteenth and fifteenth centuries. These are cultural machines that create and trap an image of desiring-production, simultaneously producing and propounding the version of the self (the lovelorn knight, the object of courtly love) that is inevitably disseminated throughout an entire society. Cinema is merely the latest in a long line of machines whose function is to produce such subjectivity. It is a machine that is plugged in to both the state and the individual, ensuring that the latter always adheres to the models the former relies on. However, as we shall determine, Guattari does assume that cinema has a unique place in the arts. Its utilisation of movement, sound, colour and time allows it to offer a range of different experiences that can be both liberating and repressive in

equal measure. Or in Guattarian terms, it can encourage molecular revolution or result in the stultified reterritorialisation of an Oedipal molarity.

Look in any book on Deleuze and film and you will find the term 'minor cinema'. This is, perhaps, one of the more widely theorised Deleuzian concepts and has quickly established itself as both useful and easily applied. The term 'minor' was explored by Deleuze and Guattari in their book on Kafka, *Towards a Minor Literature*, and relates in simple terms, to the use of a dominant voice or register by a subjected or excluded group. The minor voice is inherently political. It cartographically describes a 'people to come' rather than one already in existence. In this way it should be distinguished from the notion of a minority voice, whose identity of course has already been established as being in opposition to the majority. Minor literature is not the literature of the marginal but refers instead to the kinds of tonal difference between the major and minor keys in music. The same tune may be played, but the feel, the effect, is noticeably different. Minor literature then, is language but in a minor key that undercuts the major voice from within. It should be seen as a form of political and ontological becoming, a kind of semiotic shoot that is only just beginning to grow. But it is one that still needs to survive in the earth of the dominant language.

Deleuze and Guattari assert that Kafka, a Czechoslovakian Jew writing in German, provided a form of minority voice to a language that was both powerful and oppressive. His use of a particularly official and clerical form of linguistic German can be seen as a kind of soft subversion, using the very tools of the state against itself and providing a line of flight from the molar structures of an all-powerful regime. Kafka wrote in German but his art was directed primarily for a people to come, the new breed of Czech national that strove for their own identity after the First World War. In this regard, it self-consciously strove to form new territories with new identities, rather than concretising existing

ones. Since his death, Kafka's work has been used as a form of talisman against all manner of oppressive regimes, as well as a warning against the blind acceptance of fascism and continues to speak to a people to come.

In *Cinema 2: The Time-image*, Deleuze highlighted the emergence of a new political cinema that attempted to utilise the language and discourses of Hollywood narrative in much the same way Kafka had done with German. Minor cinema, like minor literature, is inherently political. It effaces the boundary line between public and private spaces, making every act a political one, and every statement one of both individual and national importance. The 1972 film *The Harder They Come* could be viewed as cinema working in a minor voice. It utilises the usual tools of Hollywood film production – narrative, pop music, references to popular culture, heroic characterisation and so on – but encourages its audience to critique the very language that it employs. It is also quite clearly addressed to a people yet to come: Ivanhoe Martin (Jimmy Cliff) is a form of everyman for a disaffected black youth caught within the desiring regime of an outmoded white colonial past. Both in terms of its themes and its visual style the film reaches out to an audience of potential rather than one already in existence. Martin is pictured as part revolutionary, part rock star. He is, however, never a minority or a marginal, and *The Harder They Come* is not a film about oppression or political struggle but about a reaching after a consciousness that is continually becoming and transforming from the inside. His very mode of expression (reggae) becomes an act of self-determination, and it is used both as a way to assert his identity and his difference from the existing regime.

Damian Sutton and David Martin Jones cover minor cinema thoroughly in *Deleuze Reframed* so there is little need to go over it here at any great length. However, what they, and virtually every other writer on minor cinema, fail to mention is Guattari's input into this idea. Even from the short overview above we can clearly

see his fingerprints present: the striving of the minority voice is the same as the subject group enunciating their own identity. The effacement of the public and private spheres could be viewed as an act of transversality, and the deterritorialisation of the dominant mode of expression is clearly an example of molecular revolution or soft subversion. By conceiving minor cinema as a purely Deleuzian notion we understand only half of its usefulness, and by eliding Guattari's influence we miss some of the idea's power. Deleuze's conceptions in *Cinema 2* offer a precise and well-formulated taxonomy of how minor cinema is formed but does nothing to examine the methods by which it comes about. How is it created? How does it work on the audience? What is the difference between the images of minor and the images of major cinemas? These are questions that are only answered in Guattari's short essays and it is to these that we shall now turn.

Guattari, Metz and a brief stroll around semiotics

Before we look at Guattari's essay it is necessary to refresh our memory of the work of one of film theory's founding fathers: Christian Metz. Two of Metz's books *The Imaginary Signifier* and *Film Language* have become foundational texts on many university film courses in Europe and America and have been endlessly anthologised and quoted in textbooks and collections. Metz's work represents a coming together of two of Guattari's deepest interests – psychoanalysis and semiotics – and so it is no surprise that he appears in one of Guattari's most sustained statements on film 'A Cinema of Desire', first published in 1973.

Mirroring the intellectual zeitgeist of the time, film theory underwent a transformation during the 1960s and 70s. It developed from the classical period of Andre Bazin and Siegfried Kracauer, to the cinelinguistic and cinepsychoanalytical period dominated by second wave *Cahiers du Cinéma* critics like Metz himself and Jean Louis Baudry. Metz and Baudry were armed with critical tools borrowed from other disciplines (mainly linguistics,

political analysis and psychoanalysis) and applied them to film in an attempt to not only study individual texts and cinema itself, but, at the same time, to shore up its disciplinary boundaries. One of the central questions of Metz's early career was: Can cinema be thought of as a language? Could the linguistic structuralism of Ferdinand de Saussure be applied successfully to film? The answer, for Metz, was yes... and no. Whereas film could be seen to have some of the elements of language (it is connotative, it is expressive; it has recognisable elements that are transferable from text to text and so on) it cannot be thought of as a *language system*, a langue, *per se*. Metz offered three main reasons for this conclusion: firstly, film is not intercommunicative, i.e. there is no system of exchange between two parties (the director may *speak* to you as an audience member but there is no way of you actually speaking back to them other than writing an email or letter). Secondly, unlike the linguistic sign that consists of a signifier and signified connected arbitrarily, the cinematic image is, by its very nature, a representation of that which it relates to: an image of a chair on screen, for example, is not arbitrarily connected to the notion of chair, it is a direct representation of it. Thirdly and most importantly, for Metz, the cinematic sign lacked double articulation. Any natural language is formed from a small group of units that are combined to create an infinite number of utterances. English only contains 26 letters and yet they can be combined to form a potentially infinite number of words and phrases which can, in turn form an infinite number of utterances and so on. Cinema has no such unit, the shot (which has been posited as the smallest element of a film) is already a collection of elements arranged in a frame and the scene likewise. There is no basic unit upon which double articulation rests.

For Metz then, film could never be thought of as a system in the vein of a spoken or written language. Its content is far too varied, its semiotic registers too numerous, its perspectives too polyvocal and the experience too multilayered to be able to be

reduced to the structuralism of linguistic semiotics. When we are faced with such numerous registers of communication (spoken language, written language, colour intensity, music, movement etc.) the kinds of meaning transference that Saussurean analysis relies on becomes hard to assert. It is this point that Guattari picks up on in 'A Cinema of Desire' when he says:

Its matter of content extends so much more effectively beyond traditional encodings, since the semiotic alloy that composes its matter of expression is itself open to multiple systems of external intensities … its matters of expression are not fixed. They go in different directions. (Guattari, 1996: 151)

For Guattari, the control of the semiotic system, the system of meaning within society, is a key way that models of normative behaviour are proliferated, and their contraries repressed. One of the characteristics of post-industrial capitalism is its complete domination of the semiotic system. Pick up any daily newspaper and you will see how our reality is continually produced through language and the control of meaning: 'the reality imposed by the powers-that-be', asserts Guattari, 'is conveyed by a dominant semiology' (Guattari, 1996: 144) and it is this that constitutes a great deal of our social relations. By using social machines such as the media, education, family and so on, the powers-that-be can proliferate subjectivities by controlling the images we have of ourselves. The equation for Guattari is simple: whoever owns the system of meaning also owns the power.

However, some cinema offers a way out of the semiotic control of the dominant voice by appealing to registers that do not necessarily result in the construction of fixed meaning or interpretation. He called these registers 'a-signifying semiotics'. A-signifying semiotics are the molecular becomings of cinema that we examined in chapter two. They relate to our experience of colour, non-linguistic sound, movement, the rhythm of editing and so on – in fact, all of the elements of cinema that cannot be

reduced to a simple arithmetic of meaning and interpretation. A-signifying semiotics consist of partially constructed or broken signs that no longer function as carriers of ideology. Instead they are left to form schizoanalytic connections with an audience, prompting them into different spheres of experience and different ontological or even physical encounters. This is not so much a political act as one of cartographically exploring what lies beyond the boundaries of the fixed self, traversing the borders of what you know as 'you' and connecting with someone else's reality in a space that is transversal and communicative. A-signifiying semiotics are to be experienced, not analysed and thus escape the domination of the 'semiologies of signification' Guattari equated with the majortorian voice.

Badlands

Guattari rarely utilised the traditional taxonomies of film theory. He would mix analysis of classical and popular cinema, studio and auteur productions, First and Third World directors and narrative and documentary film with no overall system of either film history or film theory. Whatever film served his purpose or argument at the time he would use. Sometimes, he displays a mixture of dogged determination and naivety in his textual analysis. Such a method, however, arose not out of ignorance but out of his larger political and philosophical mandate. As mentioned earlier, although he assumed cinema to have a privileged place in the arts, he viewed it simply as part of the machinic technology of desiring-production. The evolving developments associated with cinema (the rise of talkies, the development of colour, 3D and so on) were, he thought, both opportunities for revolution and tools of a repressive system of subjection.

For Guattari, cinema could either be a 'simple, inexpensive drug' that proliferated banal and normative models of subjectivity (the father, the mother, the boss, the worker, the wife, the husband etc.) through a commercial network of consumption or a potential

technology of molecular revolution. This latter potential is because cinema allows its audiences to experience another's consciousness, and thus encourage them to make connections to groups, struggles and subjectivities that they might not ordinarily have access to.

Cinema's potential for molecular revolution extends into the very make-up of its technology. The Super 8 camera represented for Guattari the molecularisation of visual technology, not only allowing everyone access to the tools of cinematic production but also facilitating the creation of film outside of the usual bounds of narrative cinema. The Super 8 camera was, for Guattari, a tool of democratisation. It allowed a polyvocal rendering of society operating as a form of reverse panopticon, where the power of the visual would be in everyone's hands. He was to die before the widespread ownership of video cameras sparked social unrests such as the Rodney King case, or the proliferation of simple editing programs and internet-based distribution systems that allowed viral documentary films like *In Plane Site* or *Zeitgeist* to be seen by an audience of millions. However, this is somewhere close to his conception of a real political cinema, one that goes beyond the bounds of the commercial system.

In an interview for the journal *Liberation*, Guattari offered one of his more sustained commentaries on a single work: Terence Malick's 1973 film *Badlands*, starring Martin Sheen and Sissy Spacek. Malick's film, as Guattari correctly observes, has been somewhat unfairly grouped together with contemporary outlaw movies such as *Bonnie and Clyde*, *Billy the Kid* and *The Wild Bunch*, an association that misses much of the film's inherent value, both in terms of its character studies and its cinematic poetry. In her essay on the construction of identity in *Badlands*, Hannah Peterson highlights the opacity of both direction and performance, neither of which serve, or even seek to provide reasonable explanations for the actions and/or motivations of the two main characters:

In *Badlands*, Malick denies us this type of lucid information, suggesting that the characters may be drawn to each other, not through a conscious desire to change or reinvent, but because neither of them has any clear sense of self in the first place. Kit never at any point states his reasons for wanting to be with Holly. The only information that we are ever directly given about the subject is through one of Holly's subsequent voice-overs. (Peterson, 2007: 32)

Peterson is not alone in this view. The film's flat and distancing visual style (aided by Sissy Spacek's monotone narration) has often been seen as being indicative of a form of postmodern loss of affect that is more in keeping with the film's production date of 1973 than its diegetic date of 1958. We are never presented with the requisite information to either judge or condemn Kit and Holly as they make their murderous way through America's heartland. We are merely asked to come along for the ride. At various points throughout the narrative, Kit engages in behaviour that falls outside of the norm – he stands on a dead cow in the feeding ranch; he shoots a football; he builds a stone monument by the side of the road; he needlessly shoots in the river; and he constantly kicks cans, stones and other objects with a pair of unfeasibly ornate and oversized cowboy boots. All of these elements have been taken as indicators of the film's unwillingness to explain itself. We do not know why he falls for Holly and we do not know why he kills her father, nor do we know why he begins his murderous journey. We do not know who Kit is any more than he does. Kit and Holly are merely two innocent child-like symbols of America's past heading for a future that no longer holds any attraction for them. Their lack of interest in life is matched only by society's lack of interest in them. Some of the critical responses to Malick's film can be summed up using the words of film critic and philosopher Stanley Cavell when he says that, 'it is a film that invokes and deserves the medium's great and natural power for giving expression to the inexpressive' (Cavell, 1980: 245).

Guattari recognises that *Badlands* can be characterised by a lack of explanation and a loss of affect. However, he refuses to believe that this is due to some postmodern reverie that drives Kit to murder and madness. For Guattari, Kit is crazy from the beginning, and the film is a form of schizoid journey for both him and the audience. Time and time again he tries to break out of the ties of Oedipal constraint. He does this firstly by adopting the persona of James Dean, then by killing Holly's father, then by living a form of perennial childhood in the woods and, finally, by attempting to mythologise himself as a Wild West outlaw, giving his own mementos to whoever will have them. Each of these can be seen as lines of flight from the molar Kit that has been shaped and moulded according to the expectations of Middle America (the job, the wife, the children).

Malick's repeated use of the colour blue, together with the jarring and strange non-diegetic music, the fractured editing and the periods of poetic visuality are, for Guattari, examples of a-signifying semiotics that have no innate meaning, but instead need to be experienced and internalised. Indeed, the audience is able to feel some of the distorted reality of the schizophrenic in *Badlands*. At the same time it also feels some of the painful intensity of colour, the confusion and poetry of life and the banality of death. Guattari describes *Badlands* as a schizo-film. It is both confusing and intense, two fairly typical constituents of the schizophrenic experience. It maps out the schizoid flows of Kit who is free and open to follow them where they lead him. He is a figure of deterritorialisation in the same way that Holly is a figure of reterritorialisation. He is a one man molecular revolution, existing outside of the law and inevitably transforming those who come into contact with him.

Badlands is more than a mythic and poetic evocation of an America passing into history. It is a journey outside of the self. Through its use of a-signifying semiotics it unnerves and unsettles the audience who *ipso facto* come to experience some of the terror

and banality of the schizoid mind. For Guattari, this was the true function of cinema. Through this form of transversal exchange it could encourage the various political transformations that Deleuze spoke of in such depth, and initiate the molecular becomings of soft subversion. Although Guattari's reading of *Badlands* is contentious (he disagrees with virtually everyone on the nature of the narrative including Malick himself), it does illuminate many of its salient features and also explains why it failed to do well at the box office. The alienating nature of Malick's direction, whether we see it as a product of the character's postmodern affect or their inherent madness, also alienated the audience – a situation that might well have fascinated and enthralled Guattari but did little for the average movie-goer in the early 1970s.

Minor cinema is not necessarily revolutionary in the political sense. However, it does entail a revolution of the self, as it is renegotiated and reconfigured in the face of another's experience. The onto-political tenets of Deleuzian minor cinema only make sense we could contend, when seen in conjunction with Guattari's more transversal notions. If cinema reflects and shapes our desires, it can also be used to set them free, to ensure that we are open to connect with other people and groups. Cinema can make us feel some of the confusion of the insane, some of the pain of the abused, some of the fear of the victimised and some of the despair of the lost. Cinematic desiring machines connect us to other people. All we need to do is follow the flow and allow ourselves to be taken along.

Chapter 10

Ecosophy

Towards the end of his life, Guattari became increasingly concerned with the environment and green issues. He had, of course, always supported activist groups like Greenpeace and the Vert political party in France. But in works such as *The Three Ecologies* and *Chaosmosis*, he began to develop this interest into a sort of philosophical crusade that attempted to combine his interest in politics, green issues and art. For Guattari, these three areas were inextricably connected. They were rhizomatic to each other, sharing DNA, crossing over and yet existing as separate areas in their own right. Only through art, Guattari asserted, could we even hope to face the challenges that would be thrown at us in the twenty-first century. Only the affective power of the aesthetic experience could offer us a way out of the overt scientism that has both caused and prolonged the social and environmental damage of the past 100 years. Contrary to popular opinion, Guattari believed in the power of art to reach us deeply. For him it could jolt us out of our acquiescence, it could open up new existential vistas, offering a line of flight from the humdrum of the everyday.

The opening few passages of *The Three Ecologies* are as powerful as any he wrote in his lifetime:

The Earth is undergoing a period of intense techno-scientific transformation. If no remedy is found, the ecological disequilibrium this has generated will ultimately threaten the continuation of life on the planet's surface. (Guattari, 2008: 19)

By now you might have grown accustomed to Guattari's mode of writing. It was not direct, not simple and very rarely did it state things with the urgency and clarity of these lines. Guattari obviously felt that the planet was facing a very real threat, and one that had to be countered sooner rather than later. His writing takes the tone of a political manifesto here, something that, for all his politicising, he had never practised before. The environment, however, was only part of the problem.

For Guattari, the damage to the natural environment was commensurate with a similar damage to the social and psychological one: just as the oceans, seas and rainforests have been polluted by the fallout from global capitalism, so the minds and the social structures of the world's population have been polluted by its cultural counterparts. Our airwaves are as clogged up with the detritus of capitalist production as the rivers that are themselves slowly being choked of all beauty, life and spirit by industrial pollutants. In one particularly damning passage from *The Three Ecologies*, Guattari describes capitalist moguls like Donald Trump as 'another species of algae, taking over entire districts of New York and Atlantic City' (Guattari, 2008: 29) The homeless families that are forced out of the redeveloped urban apartment blocks, he says, are the human equivalent of the dead fish that float lifelessly on the polluted waters of some of the world's seas and oceans. Media images of a globalised world are generated like the plastic goods on an industrial production line. Semiotisation has become the main function of capitalist production, as the factory and the foundry have been replaced by the generation of meaning and semiotic signs. The ecology of the social economy is intimately connected with the ecology of Nature and the environment. The outcome of this is clear: we cannot have lasting change unless we confront each of these areas together and see them as part of the same integrated problem.

The recent interest in environmentalism has only served to highlight the futility of tackling ecological issues without also

addressing the corresponding fissures in the political, ethical and semiological fields. Let us take a rather well known and well publicised example. The great fast food chain McDonald's once packaged their quarter pounders and Big Macs in polystyrene packs called clamshells. A report from the World Resources Institute showed that the clamshell packs were chosen because they were easier to recycle than the waxed paper or cardboard alternatives, and, used less energy in their production. Several initiatives in the USA even invited diners to recycle their packaging in special bins that would be collected and used for insulation in local housing projects. However, clamshell packing soon became a symbol of twentieth-century waste, especially as it was linked with the environment. It became a signifier for the throwaway society and an archetypal image of our own thoughtlessness when confronted by the natural world. Pressure groups and consumer concern over environmental damage caused by multi-national businesses forced McDonald's into changing back to the more ecologically damaging waxed paper and cardboard. This move not only proved counter-productive in terms of environmental impact, but masked the real threat that such businesses pose to the environment through deforestation and transportation.

The above example is not designed to suggest the futility of environmentalism *per se*. It is used to highlight Guattari's point that real change is hard to exert if environmental issues are thought of as being somehow separate from the other processes of psychologism, society and semiotisation. When we view environmentalism in isolation – that is, when we try to tackle the manifestations of some larger deeper malaise with quick-fix techno-scientific reasoning and logic – we may only succeed in making the position worse.

For Guattari, the three main ecological systems were the environment, social relations and human subjectivity. If real change is to be undertaken, if the kinds of issues he outlines above are to be tackled fully then it has to be done on three fronts: the

natural, the social and the onto-aesthetic. The scientific paradigm has only succeeded, Guattari suggests, in alienating and calcifying subjectivity and in jeopardising the environment. At its most basic, the techno-scientific regime of the post-Enlightenment period drew false distinctions between the natural and the technological, the animal and the machinic. If any one of these three ecologies is not addressed we will simply fall back on the short-term fixes of the past, relying on science to dig us out of an environmental hole only to realise we have created another. Guattari, in perhaps the most impassioned prose of his career asks the question:

How do we reinvent social practices that would give back to humanity – if ever it had – a sense of responsibility, not only for its own survival, but equally for the future of all life on the planet, for animal and vegetable species, likewise for all incorporeal species such as music, the arts, cinema, the relation with time, love and compassion for others, the feeling of fusion at the heart of the cosmos? (Guattari, 2006: 119)

Guattari's notion of ecosophy, based on the interaction between the three ecologies and the emerging fields of deep ecology and ecologism, attempts to highlight the transversal relationship between individual subjectivity, the group and the environment. Ecosophy is more than environmental philosophy; it is a blueprint, a map, for a relationship to the world. Ecosophy suggests that we need to approach environmental issues in a heterogeneous way, spanning traditional boundaries of science, art, educational practice, architecture, economics and so on. The traditional avenues of environmental practice, thought Guattari, need to give way to an ethico-aesthetic paradigm that would also entail a redefinition of our values and basic perspectives. Art and literature should involve an inherent cartographical exploration of new territories, breaching existing borders and boundaries and putting out lines of flight in a schizoid attempt at deterritorialisation. Ecosophy employs the term 'environment' in its widest sense. It

can of course refer to nature, but it can also refer to urban and metropolitan areas, psychogeographies, existential terrains and so on. Environment, in other words, is everything around us and is us.

For Guattari, the way out of the modern media-saturated condition was not the acquiescence of the postmodernist or the wooliness of nostalgia or religiosity, but a molecular revolutionary praxis that deploys the very tools developed by techno-capitalism – the video, the internet, the computer – and attempts to redirect them for subversive means. We already have the tools for environmental, social and psychological change. We simply need to deploy them in a positive and creative manner, turning the mechanisms of capitalist subjugation into the raw material of molecular revolution. This is already with us in the form of the internet and cyberspace, both providing re- and de-territorialised movement. As Guattari suggests, this idea is not new; Caxton's printing press was perhaps the first example of how a once elitist technology can be redirected for revolutionary and emancipatory ends.

S.P.A.W.N., *Knowmad* and *Revival Field*

No artist has exemplified Guattari's notion of ecosophy more than the Texan, Mel Chin. Chin studied in Nashville in the USA and his work attempts to bring together the fields of environmentalism, local politics, art and human subjectivity through a variety of different media – from the computer generated video game to the biology of plants and herbs. Chin's work spans the borderline between scientific research and artistic endeavour and it is both poetical and scientifically useful. It asks viewers to not only engage with it on an intellectual level but to also be affected by it on an emotional one.

S.P.A.W.N. (Special Projects: Agriculture, Worms, Neighbourhood) was originally conceived by Chin in 2000 and aims to structurally re-engineer some of the many houses damaged by fire in the Devil's Night arson attacks of the 1980s and 90s. The 30 October, or the

Devil's Night, became a traditional time for arson attacks in Detroit and the surrounding area. Every year numerous houses were burned to the ground by arsonists in celebration of Halloween, leaving the local population scared and the urban environment scarred by blackened ruins. The Devil's Night became a tradition that caused fear and anxiety in the local population and it also reduced the desirability of already economically fragile urban spaces. *S.P.A.W.N.* aimed to regenerate the houses by building agricultural worm farms in their cellars. An entire house was pivoted in one corner and could be swung away from its foundations to reveal a series of bins for the growing of worms in the basement. The soil in the bins could be sold as compost, and the worms themselves supplied to the local fishing industry; not only providing a use for the dilapidated houses, but also contributing a much needed boost to the local economy.

S.P.A.W.N. interacts on an environmental, a socio-political and an economic level, fulfilling several functions at once and kick-starting the interest of local communities in activities that can affect their everyday lives. *S.P.A.W.N.* redirected local anxiety into a creative effort, taking what is in effect the outcome of vandalism, and turning it into an opportunity for environmental, economic and, most importantly, psychological change. The local residents, far from seeing themselves as victims of vandalism, claimed ownership of the houses again thus transforming and reinvigorating their collective consciousness. They become participants in their own social project, rather than bystanders to a socially divisive act by a rogue minority in their community. In this respect, the project is one of empowerment: it doesn't necessarily tackle the harmful effects of arson, but instead neutralises it through re-appropriation and redeployment. *S.P.A.W.N.* literally revealed the creative underneath the city of Detroit.

Chin's other project *Knowmad*, goes further than this. Entering the realm of software development and new media technology, *Knowmad* literally asks the viewer to interact with the processual and the virtual. Unlike many postmodern

philosophers (Baudrillard, Lyotard etc.), Guattari was largely positive about the prospect of new technology. For him, although it could entail an inherent homogenisation of subjectivity, it could also promise new and un-thought of existential territories. New personalities, new communities and new areas of being materialise that do not rely on the traditional and calcifying logic of late twentieth-century capitalism. Cyberspace is, in essence, inherently rhizomatic; it has no hierarchical logic, and within it identity is always shifting, unfixed and open to instant transformation and change. For Guattari, cyberspace was a chaosmosis – an area of indeterminate potential where molecular connections could be made, and terrains mapped and remapped at will without the constraints of traditional Euclidean notions of time and space.

Chin's *Knowmad*, as the title suggests, mirrors *A Thousand Plateaus* in which Deleuze and Guattari oppose the nomadic mind (with its tropes of wandering, cartography and the rhizome) with the rigidity and the striation of the sedentary mind (with its tropes of hierarchical organisation and regulation). *Knowmad* was a collaboration between Chin and a confederacy of software designers and was installed in the Massachusetts Institute of Technology in February 2000. Based on the traditional platform game, the architecture of *Knowmad* reflected the geometric patterning of traditional tribal carpets and formed a cartographic and ever-expanding set of virtual co-ordinates for players to move around in. The maze-like patterns not only provided an interesting and bewildering environment to explore, but also reasserted the validity of tribalism over the homogenisation of globalism by re-establishing the value of group practices in the creation of identity and the self. The virtual carpets were faithful renderings of traditional nomadic patterns from Turkey, Iraq, Afghanistan and Central Asia. Such authenticity allowed the largely Western viewer to experience some of the rich complexity of Middle Eastern culture, as a catalogue review of *Knowmad* details:

The player navigates through virtual tribal rug designs in a simulated 3D world. The experience of the game is spontaneous and generative, departing from the killing and destruction that characterise many commercial video games. (MIT, 2010)

Guattari claims in *The Three Ecologies* that technology can provide the answer to humanity's problems as well as being the source of them. This is surely reflected in *Knowmad*; a work where the traditional violence of the video game is transformed into cartographic stroll through the traditions and visual imagination of a cultural other.

In 1990, Mel Chin began what is perhaps his best known early work. As he states, *Revival Field* began as an aesthetic project to explore the poetry of biological de-pollution, but ended up as an important scientific research project in its own right. Working with Dr. Rufus Chaney of the US Department of Agriculture, Chin experimented with hyperaccumulator plants that can draw out heavy metals from polluted soil into their stems and leaves. They can also cleanse the earth in which they are planted, making it ready for further growth. Until *Revival Field*, relatively little research had been carried out on hyperaccumulator plants, and yet Chin and Chaney's work has proved convincing, with their chosen field outside of Minnesota showing significant amounts of pollutant cleansing by certain types of plants. The work, although methodologically sound, was conceived mainly as an artistic project, with Chin himself describing it as a sculpture or installation rather than scientific research, as he explains:

Conceptually, this work is envisioned as a sculpture involving the reduction process, a traditional method used to carve wood or stone. Here the material being approached is unseen and the tools will be biochemistry and agriculture. The work in its most complete incarnation (after the fences are removed and the toxin-laden weeds harvested) will offer minimal visual and formal effects. For a time, an intended invisible aesthetic will exist that can be

measured scientifically by the quality of a revitalized earth. Eventually that aesthetic will be revealed in the return of growth to the soil. (Chin, 2009)

The transformative element of the plant serves as the aesthetic practice, and the work itself spans numerous different ecologies – not only those connected with the environment and the biosphere, but also those connected to the formation of local communities and individuals through its volunteers and scientists. *Revival Field* encourages transversal connections between disciplines and modes of thought and asserts the real world value of the aesthetic experience. For Chin, it is the poetry of the de-polluting act that drives the work. The science is an offshoot, a line of flight from the original terrain. The aesthetic process is complete only when the now cleansed ground is replanted, and the earth returned to the state it was before the heavy metal contamination. The final product of *Revival Field* then is an absence, a space that once housed a living processual artwork. The open field, however, is once more part of a thriving ecology, and the knowledge gained from it feeds back into other projects elsewhere.

Taken as a whole, the work of Mel Chin represents a clear example of Guattari's three ecologies. It attempts engagement on an environmental, an artistic and an existential plane, fusing old and new technologies together to form virtual environments – whether that is through the biosphere or through cyberspace. It is the transversal nature of Mel Chin's work that elevates it above the mysticism that so often dogs so-called eco-art. For Guattari, no amount of tree hugging can save the planet from the disastrous pollution and abuses of the late twentieth century. What was needed was a complete refocusing of our energies and values. This may be a difficult process but as projects like *Revival Field* and *S.P.A.W.N.* show, it is a distinct possibility.

Eco-activist art

Since the 1970s, Helen and Newton Harrison have been fusing ecological issues with aesthetic practices. Their work not only focuses on nature and the environment but actively engages with it through ongoing research and public activism. In 1977, for example, they began contributing to the Art Farm project at a spoils' pile reclamation site in New York. The spoils' pile was gradually recovered with earth and organic material collected by the local community and turned into a thriving bio-diverse meadow. The project was so popular that it had to be cut short, because park workers feared being overrun with contributions of topsoil and earth. As with the work of Mel Chin, the Harrisons' project began as an artwork and gradually transformed both the local community and their environment.

In 1989, the Harrisons attempted what was on the surface an ambitious and far reaching project set in the heart of the former Yugoslavia. They were invited by the Berlin Botanical Gardens to contribute to the formation of a nature reserve. Situated in the area between the capital Ljubljana and Beograd, the land was under threat from nearby industrial farming. What the Harrisons produced was a truly transversal art project that encompassed not only poetry and photography, but also contributed to the setting up of a nature corridor along the River Sava. Their proposed nature reserve followed the contours of a map produced in the eighteenth century, a fact that tied the land to its pre-industrial history, evoking memories of former existential terrains for the local community, who themselves worked with scientists and ecologists to maintain the ecological integrity of the reserve.

In a paper for the Creative Rural Economy Project at the Robert Gordon University, Anne Douglas and Chris Freemantle proposed the image of the artist as a leader. In a world of increasing social tension between politicians and the public, they asserted the artist is slowly being seen not only as a commentator but as a leader in issues like the environment and personal liberties. In relation to

popular culture we can see this in terms of the celebrity endorsement of projects like Al Gore's *An Inconvenient Truth*. However, in the realm of conceptual art this can take the form of works like that of the Harrisons and Mel Chin, where the landscape literally becomes the block of marble out of which they carve their work. But this is only part of the story. The true importance of works like *S.P.A.W.N.* and *Breathing Space for the River Sava* lies in their ability to span the disciplines and to bring together otherwise disparate active fronts.

For Guattari, cultural ecology was as polluted as the natural. Nature, as he states, cannot be separated from culture, and therefore relying on the quick-fix of popular environmentalism merely prolongs the problem. What is needed is a widespread shift in thinking – a micro-revolutionary change in individual psychology. Molecular revolution of desire is itself an ecological force. It spreads out, forming connections with other bodies. It creates becomings, is ever-growing and expanding, gradually breaching its borders only to re-form elsewhere under different guises and in different terrains. *The Three Ecologies* – the environmental, the social and the existential – are so intimately connected that we cannot have one without the other two, and this can only be done through an ethico-aesthetic perspective.

The recent damage caused by Hurricane Katrina in parts of New Orleans describes exactly the merging of existential, environmental and social ecologies, and highlights how intimately connected they are. It soon became apparent that the disaster left in the wake of Katrina was more than environmental. A report by the Center on Budget and Policy Priorities shows that many of the families that were hit hardest were already on a low income, suffering from high levels of unemployment and social exclusion. An estimated 30% of those affected had incomes that were well below the poverty line and many were from the densely populated African-American districts, highlighting that more than one ecological system was threatened where the winds blew through.

The issues raised by Katrina had to be tackled on several fronts – economic, environmental, racial and so on. Each contributed to the problem and so each had to be considered in the solution.

We can assume that Guattari was optimistic about the future of humanity in the face of such overwhelming problems. His constant generation of ideas was a testament to his position as both a commentator and an activist. In his final books he urged his readers to not only go out and campaign for real change, but also affect change within themselves. Only when this was done could disaster be avoided. You have been warned! He was passionate about this and he wanted us to be so too. Despite the deep depression he felt in his later years, Guattari was always committed to engagement and seeking socio-political change. It drove him and, we could hazard a guess, was a contributory factor to his tragically early death. As this chapter has shown, there are artists working in exactly the terrain that Guattari mapped out. They attempt to make not only an aesthetic but a political statement, exploring in their work the intersections between humanity and the natural world.

Conclusion: Guattari reframed

An unquiet mind

In 1982, interviewer Sonia Goldfelder asked Felix Guattari a difficult and leading question: Who is Felix Guattari? His answer was incomplete at best. In France he was mainly a psychiatrist. He helped run a hospital for the mentally ill and had done since the mid-1960s. He was not an academic as he was not affiliated to a university, and therefore his hold on the cultural and academic life of his country was limited. In Brazil he was a revolutionary political thinker. Though his influence was not great, he still enjoyed a successful tour there in 1982, where he met with party leaders, intellectuals and various members of the left. In America he was known as the latter half of the team that brought you *Anti-Oedipus* and, for the rest of the world he was virtually unknown.

In this interview, however, in a moment of pure insight, Guattari also outlined his relationship to the fields of politics and social movements: 'Ever since I was a teenager I've been interested in social movements, militant movements. I've always remained interested in them, which may be a remnant of childishness, or immaturity because generally these things stop at a certain age' (Guattari, 2007: 442). This is exactly the picture we see coming out of his work: Guattari as child, both in the positive sense and the negative. Without such childishness it is unlikely he would have remained as idealistic and as committed to change as he was. Whereas his contemporaries developed their academic careers, sometimes abandoning the radicalism of their youth, sometimes embracing and developing cultural philosophies that

denied the possibility of real change through concepts such as 'the end of history' and postmodernity, Guattari never lost the thrust and energy that we can easily detect in the pages of *Anti-Oedipus* and that drew so heavily from the spirit of the May 1968 protests. He never abandoned his commitment to his patients; he never stopped searching for new and better ways to approach injustice, inequality and social issues.

It was Guattari's childishness that provided some of the impetus for his interest in a wide range of political causes: from the Italian free radio to the identity struggles of Brazilian homosexuals. Yet it was also his childishness that held him back as an intellectual. His ideas, although powerful, are sometimes unformed and confusing, mixing passages of great clarity with sections of almost impenetrable obscurity. He was fond of drawing diagrams that tended to muddy the points he was making rather than clear them up. He was not averse to using neologisms and often utilised concepts in a flexible way, stretching their meaning and relevance beyond breaking point. His work is sometimes difficult, but it is always challenging and one suspects always written with a better world in mind.

Deleuze and Guattari's books are being increasingly used by all manner of different disciplines: art, architecture, cinema, social theory and politics. Every year more and more books are being written that apply their work. When I was preparing to undertake my PhD, initially I wanted to write what I called a schizoanalysis of everyday life. Taking a lead from Freud's work, this was intended as a work that would schizoanalyse the world about us – the lottery as a body without organs; the faciality of the modern billboard; the role of micro-fascisms in the classroom or modern office. However, my plans for this were curtailed when it was pointed out to me that the official guidelines for the funding body I was aiming at highlighted the 'proliferation of studies dedicated to the work of Deleuze and Guattari especially as it related to popular culture'. Without knowing it I had

discovered a bandwagon that was, obviously, groaning with people already. Instead, I jumped off and ran beside it for a bit knowing that it was going to some interesting places!

In his last book, Guattari offers a vision, a hope even, for the future. He says:

The future of contemporary subjectivity is not to live indefinitely under the regime of self-withdrawal, of mass mediatic infantilisation, of ignorance of difference and alterity – both on the human and the cosmic register...Beyond material and political demands, what emerges is an aspiration for individual and collective reappropriation of the production of subjectivity. (Guattari, 1992: 133)

The answer to the ever increasing semiotic homogenisation, thought Guattari, was not in a quasi-mystical retreat or some kind of transcendental leap of faith, but in the simple act of asserting oneself, of creating one's own identity. As we have seen, the group and the individual work as one in Guattari's thought, the one emanating and arising out of the other, the one finding consistency and coherence in the other: the group and the individual, the molar and the molecular, the macro and the micro.

For Guattari, as we have seen, art was a major way that this reappropriation can happen, because it prompts us into new and uncharted territories. It encourages us to slip the bounds of ourselves, to venture beyond the lives that are handed to us by our jobs, our education, our media and our families, and to be affected and touched by what we see and experience. Sometimes just witnessing the power of a particular shade of blue or yellow is enough to encourage you on a line of flight, to send you beyond the limits of your usual self.

Molecular revolutionaries

In September of 2010 I happened to be walking on my local railway station and heard a commotion coming from what I thought was the gentleman's toilet. After looking inside (not something that I often do in gentleman's toilets) I found that it was caused by an art

event, a happening. It was one of a growing number of what are tellingly termed 'micro-galleries' that are springing up all over the UK in spare office blocks, disused shops and, it seems, long-forgotten toilets. The micro-gallery that was housed on the railway station was small and white. Dotted around the walls were various paintings and video installations concerned with the environment and ecological practice. Travellers to the station could spend a few minutes while they waited for their next train by taking in the art and contemplating on the irony of where it was situated. The micro- gallery was organised by the family-run art movement 'Yoke and Zoom', and represents just one in a long line of similar projects that aim not only to bring art to a wider public but to situate it within the heart of the everyday experience. A similar project, 'Slackspace', attempts to do the same thing in Colchester, Essex, deep in the heart of the town centre. In an old shoe shop visitors can engage with various paintings, sculptures and installations as

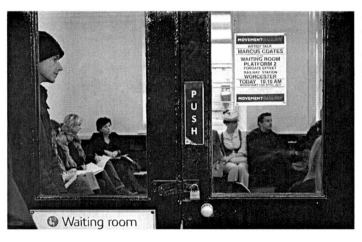

6. Yoke and Zoom, *Movement art gallery situated on Worcester Foregate Street train station* (2010).

they carry their shopping home from Sainsbury's or as they pop out to the newsagents for a paper and a pint of milk.

It is easy to see the connections between Guattari's notion of molecular revolution and such projects. Each is based on a similar idea, that the aesthetic experience can burrow under the banality of early twenty-first-century life and that the creeping cultural hegemony of media capitalism can be countered by small groups as long as they are deployed in a way that is easily accessible.

Many of the artworks we have discussed in this book were not discussed directly by Guattari, but his work resonates within them. He had a faith in the value of art and the value of the aesthetic experience, not because he thought it above the everyday but because it derived from the everyday, the stuff of existing – the very fabric of what it means to be human. Moreover, Guattari had a commitment to humanity in both its collective and its individuated sense. Ever since his time at La Borde, his work represented an attempt to make compassion a philosophical device. Even though his activism and his reputation as 'Mr Anti' was to colour his public persona and even though he never fully emerged from the shadow of Deleuze, hopefully *Guattari Reframed* has gone some way to highlighting just how important his ideas were to poststructuralist, post-modernist thought. Perhaps more importantly it has shown how important they might be to the future of all of us.

Guattari is of course illuminating and infuriating in equal measures. Anyone who has tried to tackle some of his solo books has most likely come up against the brick wall that seems to inhabit most late twentieth-century critical theory. However, in Guattari, this is precisely the point; he was trying to map new and uncharted areas and this needs a language which is similarly unexplored. His use of neologisms and metaphor may be stumbling blocks but they are, at the same time, an intrinsic part of his method – breaking down language and reconstituting it so that we can avoid the semiological and linguistic traps of the past.

In many ways *Guattari Reframed* is a book about one idea: experimentation, asking 'What if?' and suggesting that perhaps things could be different. With the writings of Gilles Deleuze we get the impression that we are laying the foundations for psychological and social change, but with the writing of Felix Guattari we are invited to go out and do it. However, this need not be full-scale revolution. It might mean connecting on a deep level to an artwork that particularly moves you; it might mean engulfing yourself in a novel; it might mean refusing to pay your council tax; it might mean joining a local group or it might mean deciding to change the world step by step, bit by bit. For Guattari, we all have the power to do this, especially if we recognise the power of our own collective subjectivity. Guattarian revolution is one of affect, it is a loosening of desire. He encourages us to reach out and connect with others and to also re-connect with ourselves. In his early work he attempted to do this through psychiatry, in his work with Deleuze through philosophy and in his later period through politics and the environment. Towards the end of his life Guattari managed to draw condemnation from both the left and the right wings of conventional politics, chiefly because his mandate extended beyond the usual bounds of political discourse and into more existential, virtual terrains. However, he was always committed to change, always dedicated to making the world a better and fairer place to be.

We began this book with the assertion that when people talk about Deleuze they are almost always talking about Deleuze and Guattari. This is likely to always be the case. Deleuze was the more prolific writer, he was also the more celebrated academic and he was well connected in philosophical circles. Guattari, however, as we have seen here was a vital part of the partnership. He was the spark that often ignited the fire of Deleuzio-Guattarian discourse and the kindling that kept it going. In his eulogy to his friend, Deleuze stated that the best way to keep Guattari alive was to discover his work. I would disagree: the best way to keep Guattari

alive is to embody what he stood for: engagement in life, in politics, in the environment and in art. For Guattari, feeling was resistance to the calcifying and stultifying forces of early twentieth-century capitalism. To keep Guattari alive, we should allow ourselves to feel the pain and the pleasure of living and we should see that for what it is: a revolutionary act. Go on, be like Felix, it may be our last chance.

Glossary

These are just some of the concepts that you might meet with in Guattari's work and consequently in this book.

affect – The concept of affect in Deleuze and Guattari goes beyond any simple notion of feeling or sense, although it is certainly connected to them. It is the pre-personal de-subjectivised product of an encounter between two bodies and thus involves inherent molecular becomings and mutual contagion. In *What is Philosophy?* it is taken as one of the two major constituents of the aesthetic experience, the other being the percept. It thus holds a privileged place in Deleuze and Guattari's conceptions of visual culture, art and cinema. Deleuze developed the idea of the Affection-image in his *Cinema 1 – The Movement Image* and Guattari re-worked it as an idea in the form of the cinema of desire and the a-signifying elements of minor cinema. Deleuze and Guattari state that 'artists are presenters of affects, the inventors and creators of affects' (Deleuze and Guattari, 2003: 175) not because they induce emotion and sensation in us, but because they encourage the collision of the two bodies – the body of the artwork and the body of the viewer. Affect then, is that which connects us to an artwork but also that which also prompts us to become something other than ourselves. It jolts us out of the banality of the everyday and encourages us to cross thresholds, venturing into new territories of experience.

anti-psychiatry – Guattari had many affinities with the various modes of anti-psychiatry that emerged out of the 1960s. Psychiatrists like R.D. Laing and David Cooper attempted to break down the traditional barrier between patient and doctor in a similar way to Guattari's experiments at La Borde. However, Guattari disagreed with many of the methods and dogmas of the anti-psychiatry movement, a movement that, for him failed to tackle the full scope of the analytic problem. For Guattari, environmental and social change must be commensurate with psychological and ontological change.

He cites the ill-fated experiment at London's Kingsley Hall, where a group of doctors and patients attempted to set up a psychiatric commune with no barriers and no distinctions. The institution drew huge opposition from the surrounding community, and the treatment itself was ineffectual. Guattari puts this down to Laing's insistence on the importance of the family and family-based therapy. Like most areas of his life Guattari disagreed with the tenets of anti-psychiatry but it still remained an important influence in his practical work.

becoming – Becoming, in Deleuze and Guattari is constantly opposed to Being. Being is an end point, the conclusion of a process, but becoming is concerned with the middle, the flow, the continuation of a process from one state into another. In *A Thousand Plateaus*, they cite the example of the tree: we cannot correctly say that a tree is green because it never ceases becoming-green, it is in a constant state of colour change – from light green, to dark green, to brown, to orange, to red and then back again. Never does the tree remain one colour, never does it stop transformation. They suggest that we should perhaps say instead that the tree 'greens', that it becomes green. Becoming is linked to art and visual culture though Guattarian aesthetics because it implies an effacement of borders and the creation of new territories. There is a process of becoming-aesthetic when faced with an artwork. We enter into a relationship of mutual contagion with it; our sensibilities and the sensibilities of the work/artists mix in the shared space between. In this, becoming can be read as a constituent of transversality. Deleuze and Guattari posit several concepts linked to becoming (becoming-woman, becoming-animal, becoming-imperceptible) all of which seek to deterritorialise the molar fixity of the Western phallocentric self.

cartography – Cartography is used in *A Thousand Plateaus* to oppose the practice of tracing. Tracing implies studying what is already there, a line that follows others, simply reproducing a world that already exists. Cartography, or map drawing, is different. It is a creative act that involves inherent exploration and discovery. There is experiment in cartography; the process of drawing becomes nomadic, travelling from place to place and describing the journey and landscape. Guattari utilised the notion of cartography when he applied it to psychoanalysis.

Schizoanalytic cartography encourages practitioners to follow a patient's lines of flight instead of attempting to restore some form of central identity. Cartography should map out new vistas and territories, rhizomatically forming machinic connections, strolling where the mood takes you rather than relying on a fixed direction.

desire – Desire in the Guattarian sense must be distinguished from sexual desire. Desire is pre-personal and supra-subjective. It flows beneath the level of the self and comes from within rather than being formed from some external lack, as Freud or Lacan would have us believe. In *Anti-Oedipus*, desire is inextricably linked to flows – of semen, faeces, urine, blood, money, milk – and it is the connective and disjunctive synthesis of these flows that constitutes the process of desiring-production. Desire is that which moves things along, from one machine to the next, endlessly circulating, connecting and disconnecting, caught on the flow of desire and desiring-production. Sexual desire is one of these desires but it is not different to the desire for food or for money or anything else. The key is to feed the machines, to keep them happy, to keep them running and to keep them from breaking down (because breaking down – stopping the flow of desire is as important as keeping it going). It is the pre-personal desire that is overtaken by fascist regimes, and is ultimately overcoded by the late capitalist system.

deterritorialisation/reterritorialisation – The movement between these two poles is taken as the axiomatic outcome of flows of desire. Deterritorialisation is the centrifugal working of desire. It crosses borders, breaks boundaries and is represented by molecular and rhizomatic becomings. Reterritorialisation is the equal centripetal force, bringing things together, forming mass, attempting to create the molar fixity of the state from the flows of reterritorialisation. The desiring machine attempts to deterritorialise its desire, the socious reterritorialises it creating a social animal. In this way, it is linked to the pleasure and reality principles. Deterritorialisation works through the line of flight, encouraging the body to move out beyond itself, to become imperceptible, to travel – it is the riff in jazz. Reterritorialisation is the re-grouping of the homecoming, the familiarity and security of the refrain.

faciality – The two poles of faciality are the black hole and the white wall. The white wall is that which can be projected on; it is the screen of the face that can be read. In this way it is a semiotic, creating meaning, encouraging communication and inviting interpretation. The black hole is that through which meaning escapes. The eyes of the face resist interpretation and knowability, rejecting the binary of the semiotic sign. For Guattari, faciality produces subjectivity and it is precisely the combination of that which can be projected onto and that which resist signification that creates the ontological self. The cinematic close-up is an ideal example of this. It allows (as demonstrated by the Kuleshov effect) for the projection of meaning but elides specific analysis. The closed circle of semiotic analysis is opened up in faciality via the black hole. Deleuze and Guattari are at pains to point out, however, that faciality does not only relate to the face itself but to all objects, bodies and processes that consist of this specific combination – a landscape (with its screen of projection and points of indetermination is just as much a face in faciality as the eyes, nose and mouth).

line of flight – The line of the flight is the main action of deterritorialisation. Lines of flight describe and explore new territories both physically (as in the body) or ontologically (as in desire). The line of flight is inherently revolutionary and is the first stage of molecular emancipation.

machine – The machine is a central image in Guattari's thought and appears as early as the mid- to late 1960s. For Guattari, the machine, like the biological being, evolves over time, sending out lines of flight and creating new bodies and new vistas that can provide points of departure and development. The machine can only operate by connecting to other machines, forming machinic assemblages that serve to direct flows (of oil, of money, of desire and so on). The body is not a machine but a collection of different machines, all performing some specific function and yet contributing to the whole. Machines are not necessarily physical – the media machine produces images and meaning; the economy machine produces money; the education machine produces minds. What connects each of these is the flow that is both facilitated and disrupted. The machine becomes more and more important to Guattari throughout his lifetime allowing him to escape from the bifurcated impasse of Freud and Marx.

micropolitics – The micropolitical is more than a consideration of everyday concerns, although that is certainly one of its facets. Micropolitics are molecular in nature, as opposed to the molarity of large aggregate issues such as nation states and globalisations. The micropolitical rests more in the politics of desire. We might think of it as localised and short lived. It is the politics of minutiae, the myriad of concerns and political issues that directly affect the individual: local politics, sexual politics and identity politics. Some forms of fascism are particularly invidious as they overcode and usurp the micro- as well as the macropolitical strata. Fascism may declare that it is concerned with nationhood (with Germans, with Jews) but in reality it has to do with the family, the self and the neighbourhood. Micropolitical revolution, however, can reverse or halt the war machine of fascism, using its own tools against itself.

minor cinema – Minor cinema is an offshoot from the concept of minor literature. Minor literature is that which is written by a subjugated group in the dominate language. Because of this it is inherently political and directed at a 'people to come' rather than an existing audience. The minor voice is a form of immanent critique of the major. It is molecular rather than molar, providing a line of flight from the fixity and rigidity of the dominant regime. In Guattari, the minor is more aligned with the subjugated and the minority than it is with Deleuze. Unlike Deleuze, Guattari discusses it in relation to the cinema of madness. Films like *Coup Pour Coup*, *La Ville-Bidon*, *Fous à Délier* and *Paul's Story* allow an audience access to a social and psychological minority that would not ordinarily have a voice. If a major art is the art of power (television, the media and so on) then a minor art speaks for (not necessary to) a minority.

molecular revolution – Molecular revolution is in our hands. Guattari became more and more convinced that the usual processes of revolution such as those advocated by Marx (for example, large-scale class overthrow) became evermore futile. Using his theory of subject and subjected groups, Guattari asserted that molar revolution merely resulted in more oppression and further abuse of power. He also suggested that capitalism had become so powerful, so much a part of the fabric of our very experience, that to do away with it was virtually impossible. Those who attended the many anti-capitalist marches of the late 1990s knew this only too well. As they marched against the widespread dissemination of capitalist dogma many

stopped to lunch at McDonald's and drink coffee at Starbucks – on the one hand protesting against, on the other consuming, the capitalist machine. For Guattari, the only possible solution was a continuous series of molecular revolutions. These would take the shape of micropolitical changes surrounding sexuality, identity, local politics, gender and so on. Molecular revolution occurs at flashpoints and spreads quickly but just as quickly fades, thus avoiding the stultification of its molar counterpart. Guattari witnessed molecular revolution in Brazil in the 1980s, where transformations not only occurred in the political and the social but also the psychological and sexual realms.

nomad – The figure of the nomad wanders through Deleuze and Guattari as a rhizomatic transformative figure. Although they have been accused of romanticism, Deleuze and Guattari view the nomad as more of a symbol than an actual culture. The nomad opposes fixity, moves from place to place, sends out shoots and lines of flight and is in a constant state of travel. For example, Deleuze and Guattari highlighted the specific character of nomad art. It is small, portable and intricately formed. The metal work and carpet weaving of the nomad mirror their experience of the smooth space of the steppe: the metal flows from one state into another, carpets are produced out of several strands woven together. The nomad has become particularly important. Since the proliferation of internet technologies and ever increasing globalisation, not only do we see greater and greater population transience, we also see increasing demographic slippage as the solid bodies of state and identity breakdown and become unstable. The nomad can be opposed to the self in modernity but is also an antidote to the self in postmodernity.

refrain – The refrain is a powerful concept. First developed in *A Thousand Plateaus* it describes a state of return, a home that offers shape and consistency in the unconnected flow of events. It is a point of reterritorialisation that shapes and structures chaotic movement, providing points of consistency on an otherwise undifferentiated plane. Deleuze and Guattari begin their chapter on the refrain by evoking the image of the child comforting himself by humming a familiar tune. The refrain consists of three interconnected facets – the calm centre, the perimeter and the line of flight, and any action or event that consists of

these can be thought of as a refrain. Refrains can be the chorus of a song, a repeated phrase in a novel (for example, in Proust), an image in a painting or simply a sensual and affective experience that offers shape and consistency to an otherwise chaotic and undifferentiated flux.

schizoanalysis – Guattari developed schizoanalysis to counter the centripetal familialism of psychoanalysis. Schizoanalysis is the analysis of flows and seeks to cartographically chart the new territories created by lines of flight and the production of desire. Schizoanalysis opposed the Oedipal explanations of Freudian analysis (that reduces every question to one of mummy-daddy-me) and seeks a more materialist explanation examining the role of the family and its relations in the creation of neurosis and schizophrenia. Guattari reverses the usual process of Oedipal psychiatry by asserting the influence of social mechanisms on the family and the psyche – the boss no longer becomes a substitute father figure. Instead it is the father who is the boss figure and the child the worker. The capitalist system, in other words, imprints its forms and structures on the family and thus exerts control over both bodies and minds.

subject and subjected groups – In early Guattari, the notion of the subject and subjected group described the difference between revolutionary, self-determining, emancipatory groups and groups who depend upon external forces and figures for both cohesion and identity. Subject groups set their own agendas, define their own goals and determine their own internal consistency. There is a high level of transversality between members of the group and they are by their very nature, connective and open to change and transformation. Subjected groups, however, rely on leaders and external mandates. They have very little transversal connectivity between members, and much less between themselves and other groups. Populations under a dictator, religious cults and some political parties are ideal examples of subjected groups. Subject groups, however, can quite easily turn into subjected groups, as the revolutionary and emancipatory power is replaced by a form of bureaucratic calcification. In order to avoid this, Guattari suggests that political groups and movements should act micropolitically in acts of molecular revolution that attempt to deny the processes inherent in subjection. Like the various concerns that surrounded the anti-poverty marches that accompanied the

G8 summit in the early 2000s, subject groups should be communicative, have a high impact, consist of numerous concerns but coalesce around one, be short lived and easily dispersed.

transversality – Despite Guattari doubting the value of transversality later in his career and it being usurped by more complex, intellectually rigorous concepts such as schizoanalysis and becoming, it remains one of his most enduring and important concepts. Essentially describing the levels of connectivity between layers of an organisation or group, transversality provides us with an entry point into the kinds of structures and forms that dominated his work with Deleuze in the 1960s and 70s. Transversal relations are open and communicative, they allow for individual subjectivity, but do not deny the value and influence of the group. Subject groups have a high transversal ratio. It is this that keeps them from calcification, from rigidifying. Transversality has been applied to the area of aesthetics, not only in terms of the viewer–artwork relationship but in terms of the various relationships between groups and their concerns. The political art that arose in the 1980s and that was centred around issues like gender politics and AIDS are examples of the way that transversality can be deployed to enable us to understand the creative forces at work in contemporary agitprop. The full value of transversality is perhaps only just being felt, as technologies such as the internet and global communications allow for maximum connectivity between groups and concerns.

Select bibliography

Works by Guattari

Chaosmosis: An Ethico-Aesthetic Paradigm, Sydney: Power Publications, 1992.

Chaosophy, Sylvère Lotringer (ed.), London: Semiotext(E), 1995.

Cracks in the Street, trans. A Gibault and J. Johnson. Flash Art, 135, 1987.

Molecular Revolution: Psychiatry and Politics [1984], trans. Rosemary Sheed, London: Penguin, 1984.

Soft Subversions, Sylvère Lotringer (ed.), London: Semiotext(E), 1996.

The Guattari Reader, Gary Genosko (ed.), London: Blackwell, 1996.

The Three Ecologies [2005], London: Continuum, 2008.

Secondary texts

Anti-Oedipus: Capitalism and Schizophrenia Vol.1 [1972], trans. Robert Hurley, Mark Sheen and Helen R. Lane, London: Continuum, 2004.

A Thousand Plateaus: Capitalism and Schizophrenia, Vol.2 [1980], trans. Brian Massumi, (3rd edn.) London: Continuum, 2004.

Kafka: Toward a Minor Literature [1975], trans. Dana Polan, Minneapolis: Minneapolis University Press, 1986.

Nomadology: The War Machine [1986], trans. Brian Massumi, New York: Semiotext(E), 1986.

What is Philosophy? [1994], trans. Hugh Tomlinson and Graham, Burchill, London: Verso, 2003.

Select bibliography

Bergson, Henri, *Laughter: An Essay on the Meaning of the Comic*, Charleston: BiblioLife, 2009.

Biemann, U., Black Sea Files, available online at geobodies.org/resources/_dl/06_black_sea_files?dll, 2006.

Bogue, Ronald, *Deleuze on Music, Painting, and the Arts*, London: Routledge, 2003.

Brain, Robert, *The Decorated Body*, Michigan: Hutchinson, 1979.

Brophy, John, *The Human Face*, London: George G. Harrap and Co., 1945.

Cavell, Stanley, *The World Viewed: Reflections of the Ontology of Film*, Massachusetts: Harvard University Press, 1980.

Chin, M. cited in Krug, D. Ecological Restoration, available online at http://greenmuseum.org/c/aen/Issues/chin.php.

Dosse, François and Deborah Glassman, *Gilles Deleuze and Felix Guattari: Intersecting Lives*, New York: Columbia University Press, 2010.

Erickson, Kathleen Powers, *At Eternity's Gate: The Spiritual Vision of Vincent Van Gogh*, Michigan: William B. Eerdmans, 1998.

Foucault, Michel, *The Archaeology of Knowledge*, Oxon: Routledge, 2002.

Genosko, Gary, *The Party Without Bosses: Lessons on Anti-Capitalism from Felix Guattari and Luis Inacio 'Lula' da Silva*, Winnipeg: Arebeiter Ring Publishing, 2003.

Herf, Jeffrey, *The Jewish Enemy: Nazi Propaganda during World War II and the Holocaust*, Massachusetts: Harvard University Press, 2008.

Holmes, B. Extradisciplinary Investigations. Towards a New Critique of Institutions, available online at http://eipcp.net/transversal/0106/holmes/en/print, 2007.

Kennedy, B. *Deleuze and Cinema*, Edinburgh: University of Edinburgh Press, 2002.

Keyes, George S. and George T.M. Shackelford, *Van Gogh Face to Face: The Portraits*, London: Thames and Hudson, 2000.

Lapsley, Robert and Michael Westlake, *Film Theory: An Introduction*, Manchester: Manchester University Press, 2006.

Levine, Steven, *Lacan Reframed*, London: I.B.Tauris, 2008.

Metz, Christian, *A Semiotics of the Cinema*, Chicago: University of Chicago Press, 1991.

Metz, Christian, *The Imaginary Signifier: Psychoanalysis and the Cinema*, Bloomington, Indiana: Indiana University Press, 1982.

Peterson, H., *The Cinema of Terence Malick*, New York: Columbia University Press, 2007.

Proust, Marcel, *Swann's Way*, ed. Sheila Stern, Cambridge: Cambridge University Press, 1989.

Sutton, Damian and David Martin Jones, *Deleuze Reframed*, London: I.B.Tauris, 2008.

Žižek, Slavoj, *Enjoy Your Symptom!: Jacques Lacan in Hollywood and Out*, New York: Routledge, 2001.

Useful essays

Artaud, Antonin, 'Van Gogh: The Man Suicided by Society' in Jack Hirschman (ed.), *Artaud Anthology*, San Francisco: City Lights Books, 1965.

Backer, Kristen Williams, '*Kultur-Terror*: The Composite Monster in Nazi Visual Propaganda' in Niall Scott, *Monsters and the Monstrous: Myths and Metaphors of Enduring Evil*, New York: Editions Rodopi B.V., 2007.

Klein, Melanie, 'Infantile Anxiety-Situations Reflected in a Work of Art and in the Creative Impulse' in Sandra Gosso, *Psychoanalysis and Art: Kleinian Perspectives*, London: H. Karnac, 2004.

Filmography

Avatar (2009), dir. James Cameron, Twentieth Century Fox.

Badlands (1973), dir. Terence Malick, Warner Bros.

City Lights (1931), dir. Charlie Chaplin, Charles Chaplin Productions.

Every Little Thing (1997), dir. Nicolas Philibert, Second Run.

Frontiers (2007), dir. Xavier Gens.

Hostel (2005), dir. Eli Roth, Raw Nerve.

Saving Private Ryan (1998), dir. Stephen Spielberg.

Saw (2003), dir. James Wan, Twisted Pictures.

The Harder They Come (1972), dir. Perry Henzell, International Films.

The Man Who Knew Too Much (1934), dir. Alfred Hitchcock, Gaumont British Pictures.

The Man Who Knew Too Much (1956), dir. Alfred Hitchcock, Paramount Pictures.

The Wrong Man (1956), dir. Alfred Hitchcock.

XXY (2007), dir. Lucía Puenzo, Pyramide Films.

Index

16 Beaver Group 21, 22, 23
1968 Protests 5, 46, 49, 65, 66, 86, 104, 139

'A Cinema of Desire' 118, 120
A Thousand Plateaus (Deleuze and Guattari) 3, 11, 27, 28, 42, 49, 60, 76, 77, 93, 96, 98, 101, 103, 109, 132, 146, 150
AIDS/HIV 22–23, 152
An Inconvenient Truth 136
Anti-Oedipus (Deleuze and Guattari) 3, 5, 11, 12, 25, 38, 41, 42, 45, 46, 47, 50, 56, 63, 65, 67, 98, 103, 109, 110, 138, 139, 147
Artaud, Antonin 57, 68, 69, 70, 74
a-signifying semiotics 120, 124
assemblages 21, 26, 36, 47, 56, 59, 60, 65, 66, 90, 148
Avatar 33–36

Bacon, Francis 33, 75, 86, 87
Badlands 121–25
Bagism 86
Balthus 28, 29, 31, 32
Banksy 4
Baudrillard, Jean 101, 132
Baudry, Jean Louis 118
Bazin, Andre 118
becoming-homosexual 109–12
becoming-woman 109, 146
Benjamin, Walter 53, 94

Bergson, Henri 53
Biemann, Ursula 22
Big Brother 104
body without organs 3, 57, 61, 74, 139
Bogue, Ronald 32
Bottle Rack 94–95
Bowie, David 45
Breathing Space for the River Sava 136

Cahiers du Cinéma 34, 118
capitalism 7, 12, 38, 45, 60, 101, 102, 105, 107, 109, 120, 127, 130, 132, 142, 144, 149
cartography 146
Cavell, Stanley 123
Chagall, Marc 44
Chaney, Rufus 133
Chaosophy (Guattari) 4
Chaplin, Charlie 53, 77, 78
Chin, Mel 130, 133, 134, 135, 136
cinema 1, 25, 34, 35, 37, 40, 66, 75, 78, 92, 95, 103, 115–25, 129, 139, 145, 148, 149
Cinema 1: The Movement-image (Deleuze) 145
Cinema 2: The Time-image (Deleuze) 117
City Lights 77, 78, 87
Cooper, David 145
courtly love 115

Da Vinci, Leonardo 13, 14
Dada 43, 44, 53, 61
Day, Doris 96
Descartes, René 26

desiring-production 57, 65, 66, 67, 115, 121, 147
Dosse, François 101–3
Duchamp, Marcel 94

ecosophy 126–37
embodied film theory 36–37

faciality 7, 76–87, 139, 148
fascism 6, 38, 39, 42–50, 117, 139, 149
Film Language (Metz) 118
Foucault, Michel 5, 38, 60, 61, 103, 110
Freud, Sigmund 13, 14, 15, 17, 28, 47, 56, 57, 59, 63, 65, 65, 139, 147, 148, 151
Fukuyama, Francis 27, 101

Geldof, Bob 45
Goebbels, Joseph 41
Gormley, Antony 80
groups 2, 14–21, 42–46, 49, 102, 104, 110, 122, 125, 128, 142, 149, 151

Harrison, Helen 135–36
Harrison, Newton 135–36
Heath-Robinson, William 58
Heidegger, Martin 53, 54
Hitchcock, Alfred 95, 96
Hitler, Adolf 41, 43, 44, 47
HIV *see* AIDS/HIV
Hostel 62, 63, 64
Hurricane Katrina 136–37

images of Christ 83–86
In Plane Site 122
iPhone 59–60

jazz 90

Kafka, Franz 117–18
Kafka: Towards a Minor Literature (Deleuze and Guattari) 67, 116
Keaton, Buster 53
Kennedy, Barbara 36
King, Rodney 122
Kjär, Ruth 13–15
Klein, Melanie 13, 15, 65
Knowmad 130, 131, 132, 133
Kuleshov experiment 78
Kultur-Terror 48

La Borde 2, 4, 5, 6, 11, 15, 16, 18, 19, 20, 21, 23, 33, 42, 45, 57, 66, 75, 102, 103, 142, 145
Lacan, Jacques 5, 7, 15, 16, 17, 18, 57, 65, 70, 147
Laing, R.D. 145
Lennon, John 86
Lindner, Richard 64
lines of flight 20, 26, 37, 68, 69, 87, 124, 129, 147, 148, 150, 151
Locke, John 34
Lynch, David 7
Lyotard, Jean François 27, 101, 132

machines 1, 39, 49, 53–64, 66–68, 72, 73, 77, 79, 80, 81, 85, 86, 98, 109, 112, 114, 115–24, 147, 148, 149, 150
Malick, Terence 122–25
Maoism 104
Marx, Karl 5, 47, 53, 56, 63, 148, 149
Massumi, Brian 16
McDonald's 101, 128, 150
Metz, Christian 118–19
micropolitics 38–52, 149
minor cinema 116, 117, 118, 125, 145, 149
minor literature 116

molarity 25, 26, 27, 30, 31, 33, 34, 35, 37, 70, 116, 149
molecular revolution 2, 101–14, 116, 118, 122, 124, 130, 136, 140, 142, 149
molecularity 26, 27, 30, 33, 35, 36, 37, 70
Mondrian, Piet 79
multiculturalism 85

Nazism 1, 38, 40, 43, 44, 47, 48
nomad 7, 132, 146, 150

Oury, Jean 4, 15

paraSITE 106–8
Philibert, Nicholas 19, 20
Portrait of Dr Gachet 71–73
postmodernism 6, 22, 27, 66, 81, 101
propaganda 35, 38, 39–44, 47, 49, 50, 62
Proust, Marcel 92, 93, 94, 151
Puenzo, Lucía 111

Rakowitz, Michael 7, 105–8
Reaganomics 101
Recker, Robert 86
refrain, the 88–98
Revival Field 130, 133, 134
rhizome 2, 16, 26, 59, 80, 98, 132
RISE 105–6
Ritornellos and Existential Affects (Guattari) 91
Rolnik, Suely 110

Said, Edward 84, 85
Sartre, Jean Paul 18, 45
Saving Private Ryan 37
Saw 7, 62, 63
schizoanalysis 2, 5, 7, 11, 16, 58, 65–75, 98, 139, 151
Schweitzer, Hans 40, 41
semiotics 28, 33, 36, 77, 78, 87, 118, 120, 121, 124
SILENT|LISTEN 23

Silva, Luiz Inácio Lula da 110
Sontag, Susan 110
S.P.A.W.N. 130, 131, 134, 136
Spinoza, Baruch 3, 91

Tahara, Keiichi 77
Takamatsu, Shin 7, 77, 79–81
Thatcherism 101
The Cog 58
The Harder They Come 117
The Imaginary Signifier 118
The Man Who Knew Too Much 95–97
The Starry Night 73
The Texas Chainsaw Massacre 62–63
The Three Ecologies (Guattari) 5, 126, 127, 129, 133, 136
Tinguely, Jean 55, 56, 62, 64
transversality 11–24, 42, 43, 75, 94, 118, 146, 151, 152
Trump, Donald 127

Ultra-red 20, 22, 23

Van Gogh, Vincent 6, 68, 69, 70–75

war machine 49, 149
Warhol, Andy 14, 67
What is Philosophy? (Deleuze and Guattari) 73, 145
Wojnarowicz, David 112–14
Wood, Robin 96–97

X Factor 104
XXY 111–12

Yoke and Zoom 141

Zeitgeist 122
Žižek, Slavoj 77–78